SEASONS

Hanna Karlzon

GIBBS SMITH

TO ENRICH AND INSPIRE HUMANKIND

Gibbs Smith
P.O. Box 667
Layton, Utah 84041

1.800.835.4993 orders
www.gibbs-smith.com

ISBN: 978-1-4236-4808-6

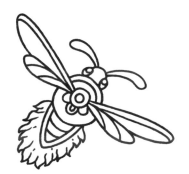

Also available! *Seasons* postcards

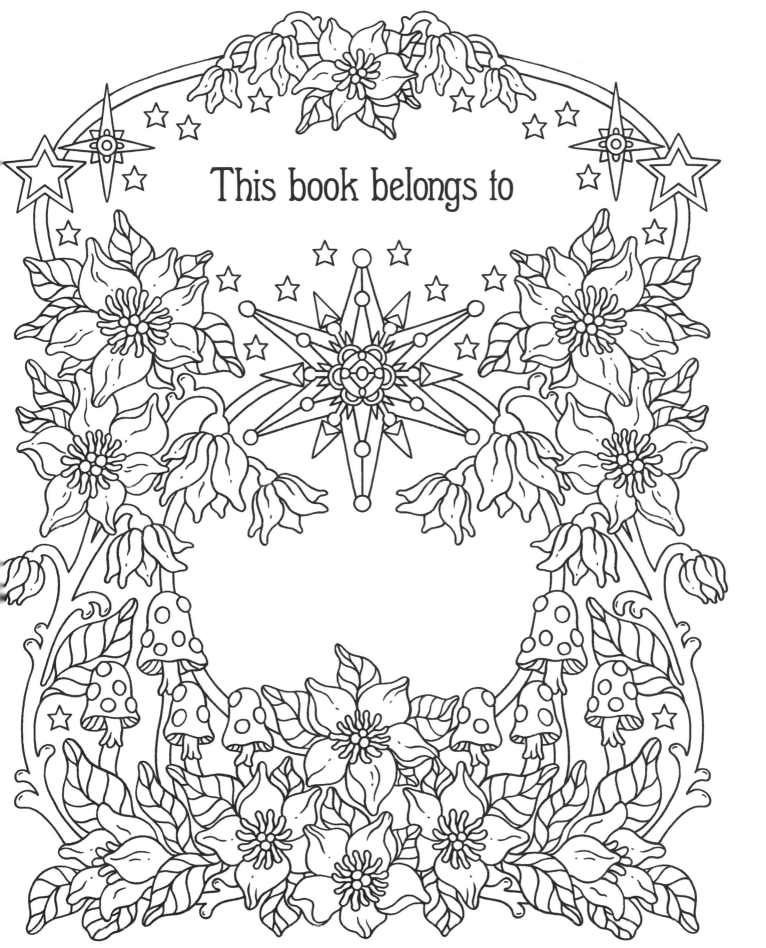

This book belongs to

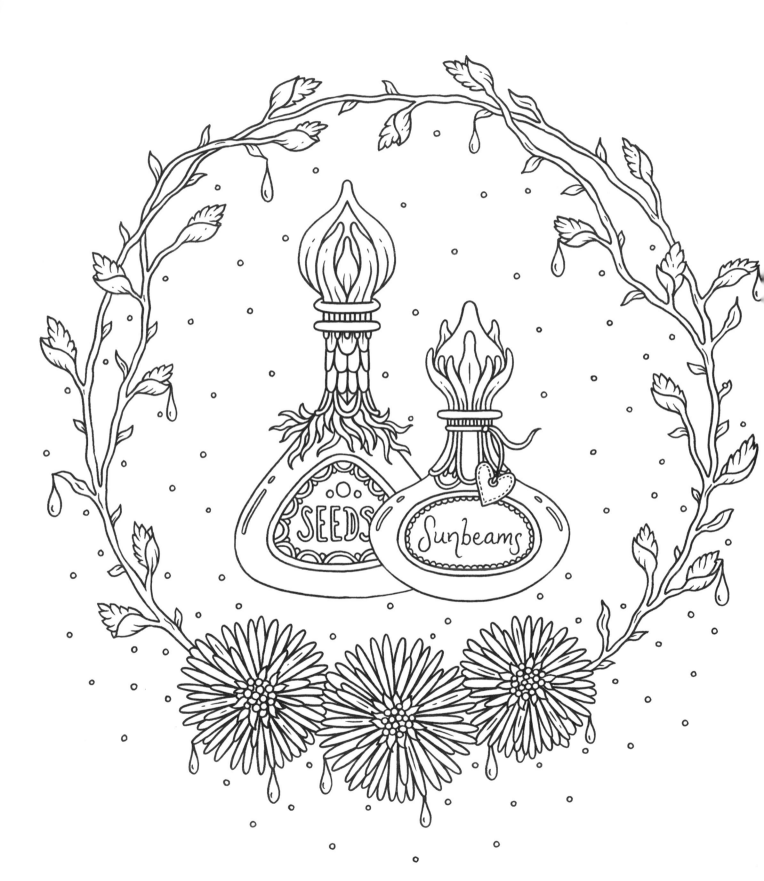

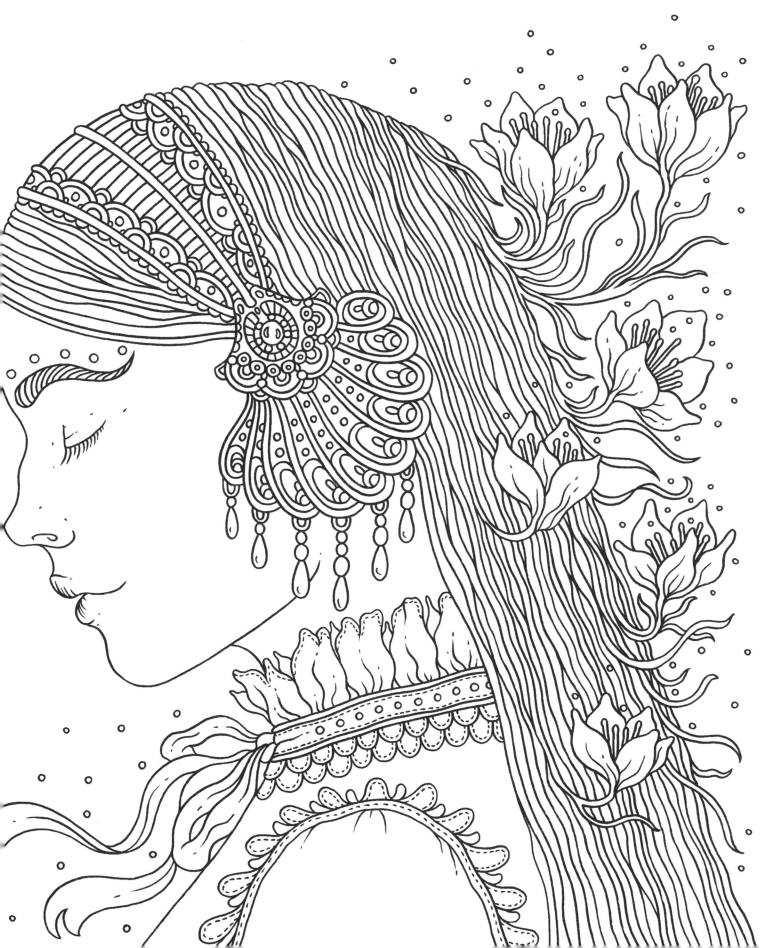

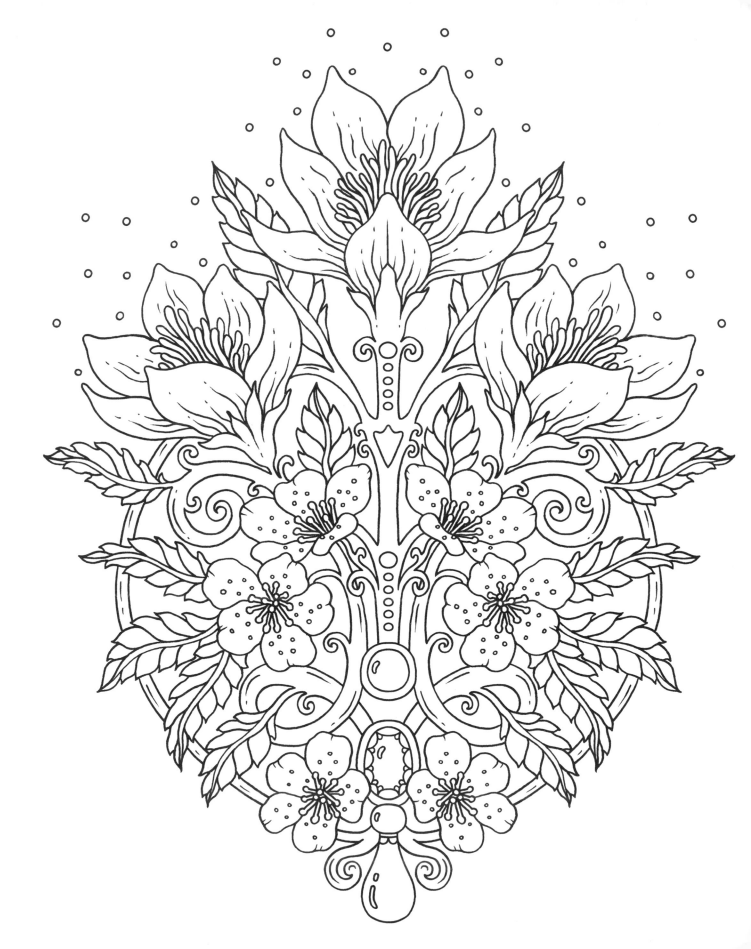

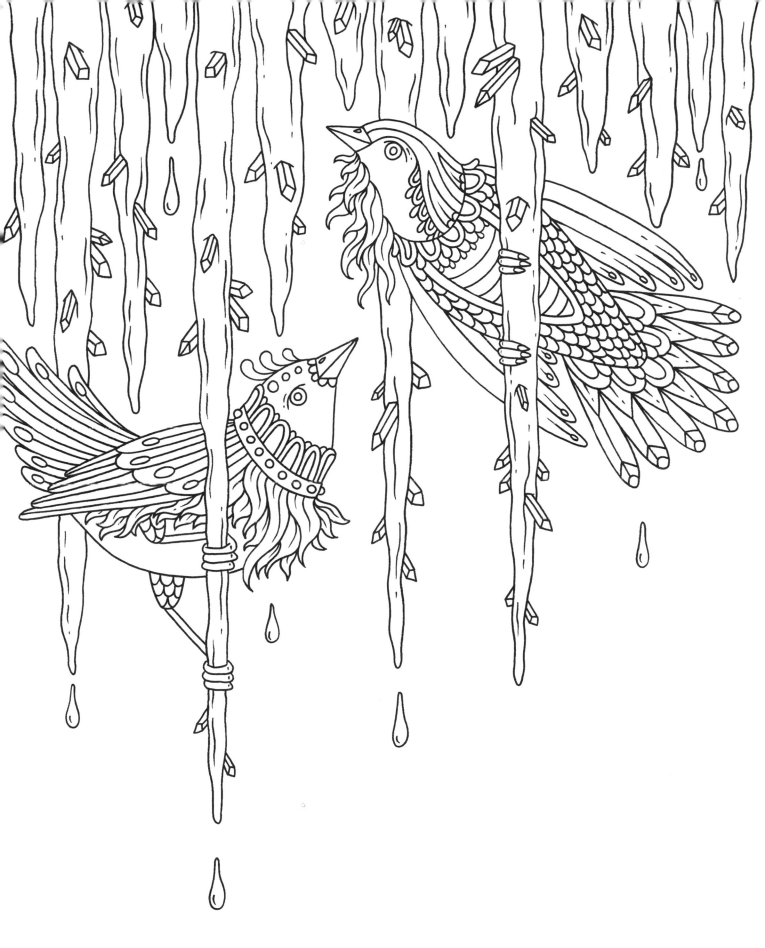

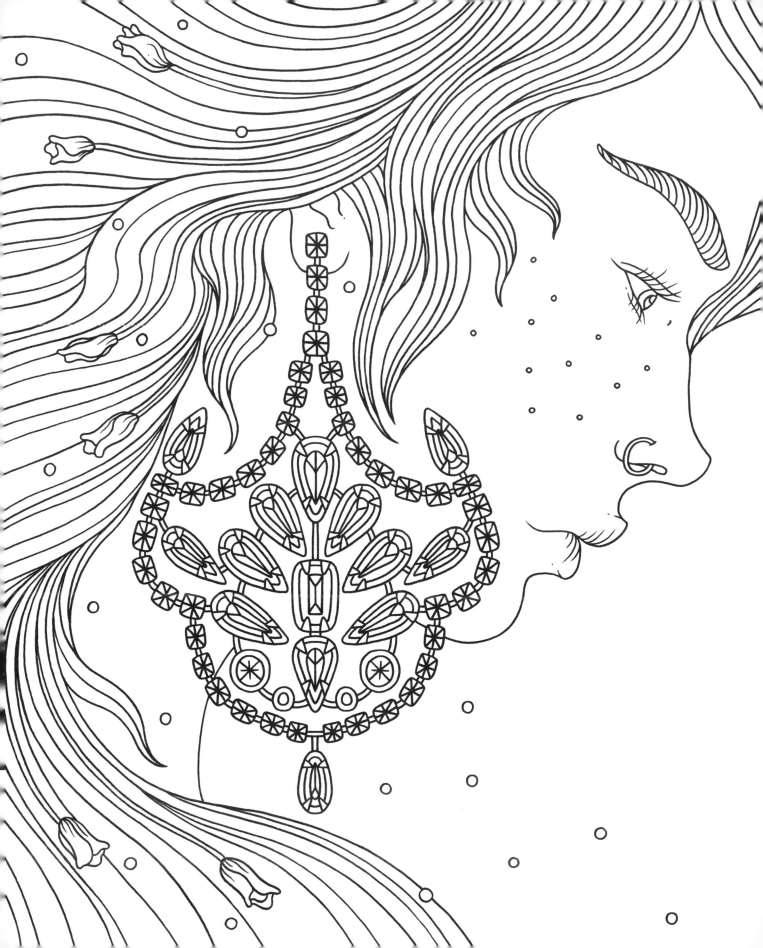

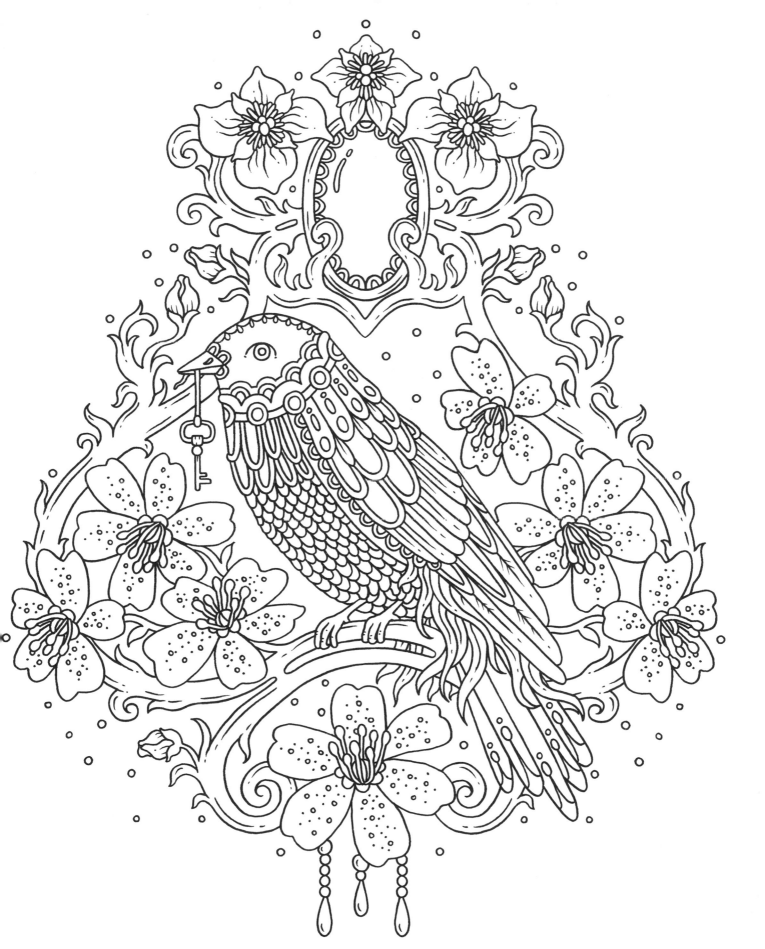

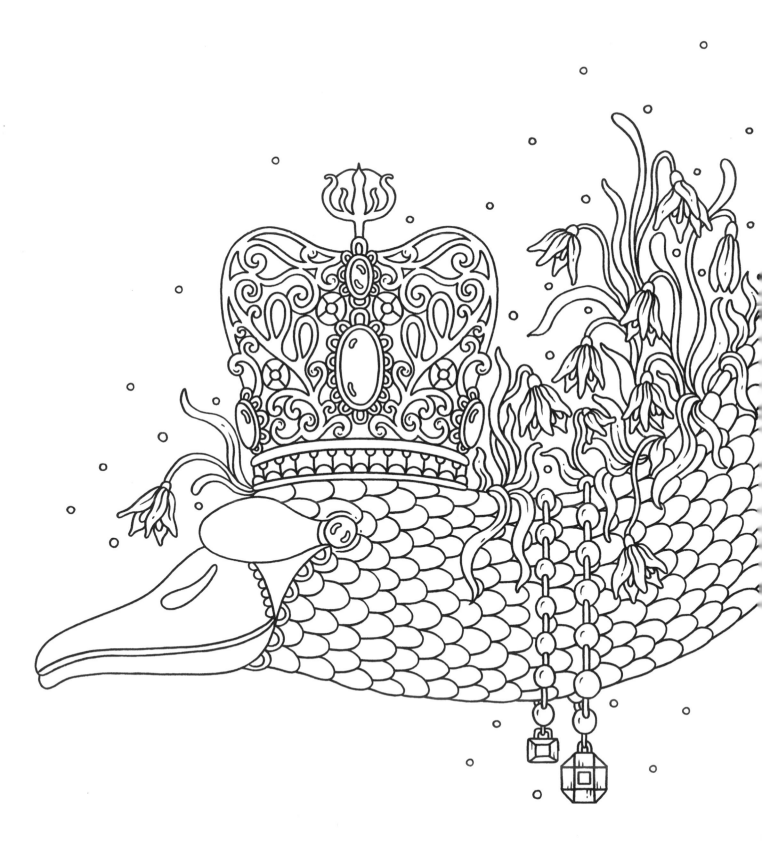

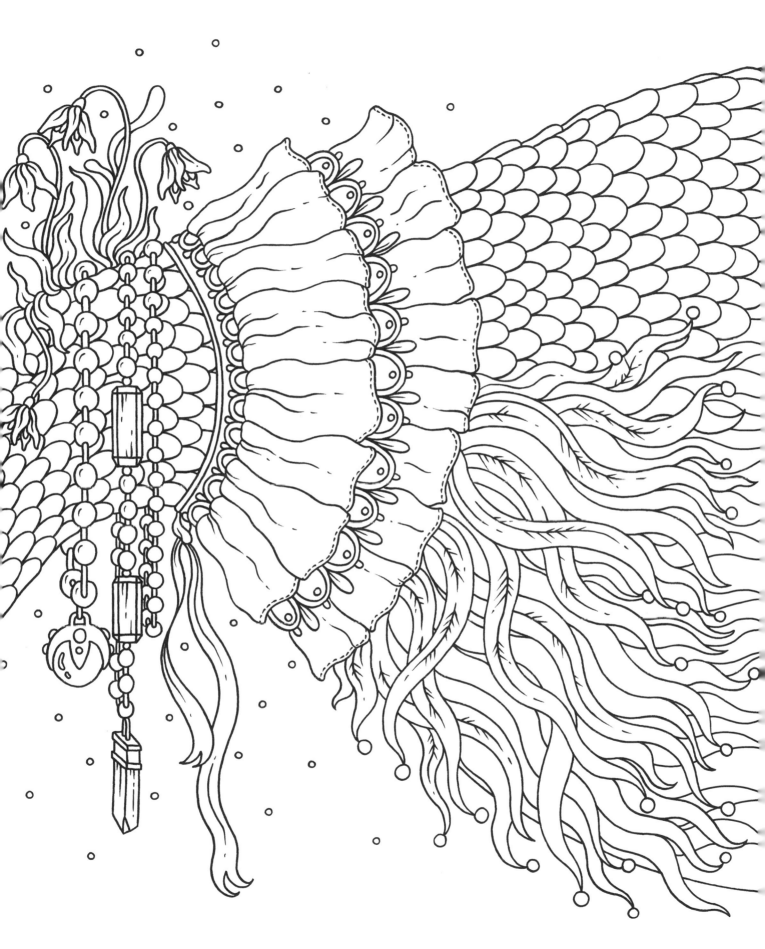

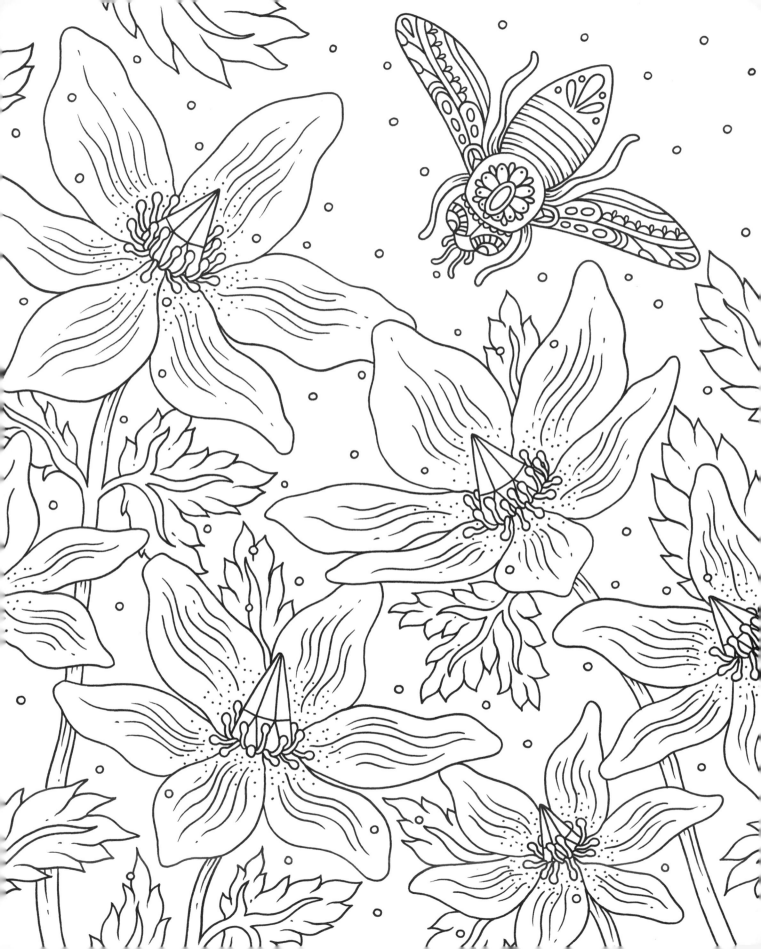

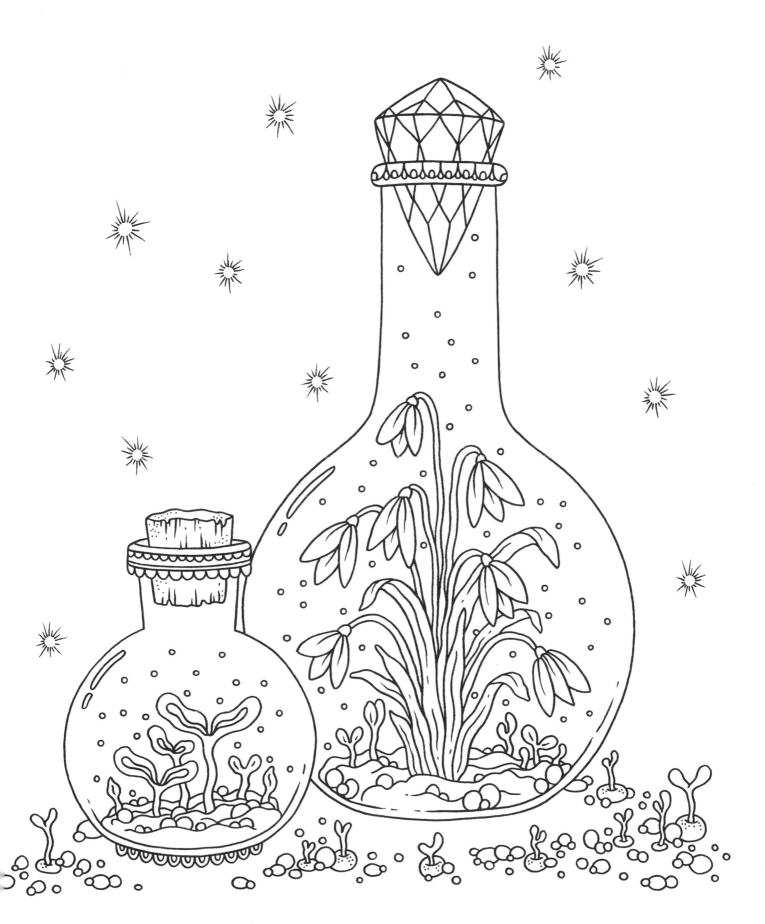

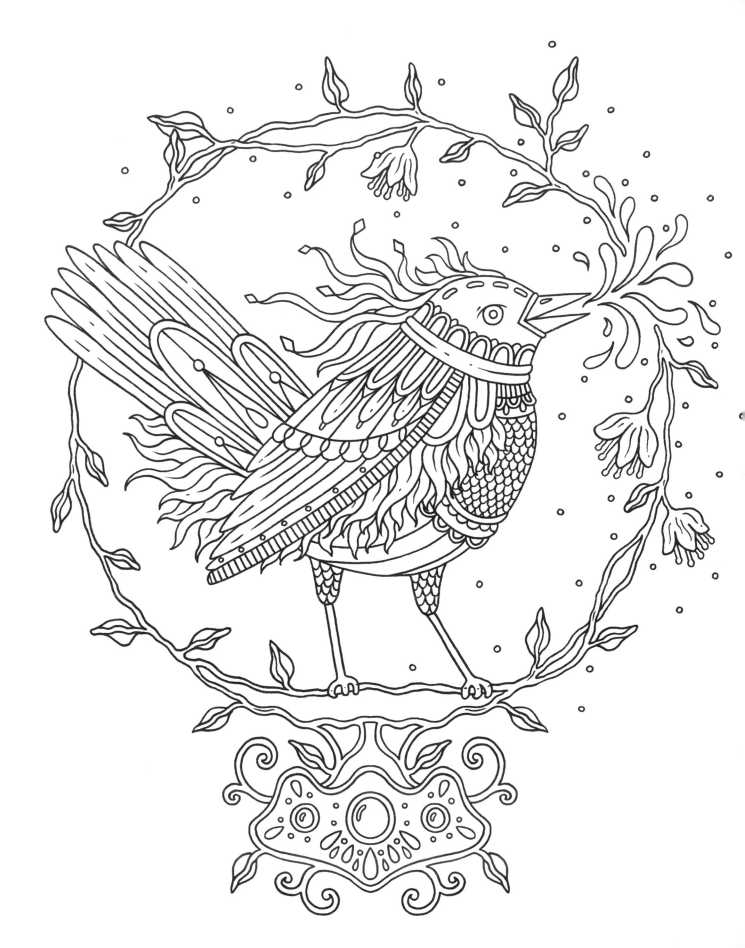

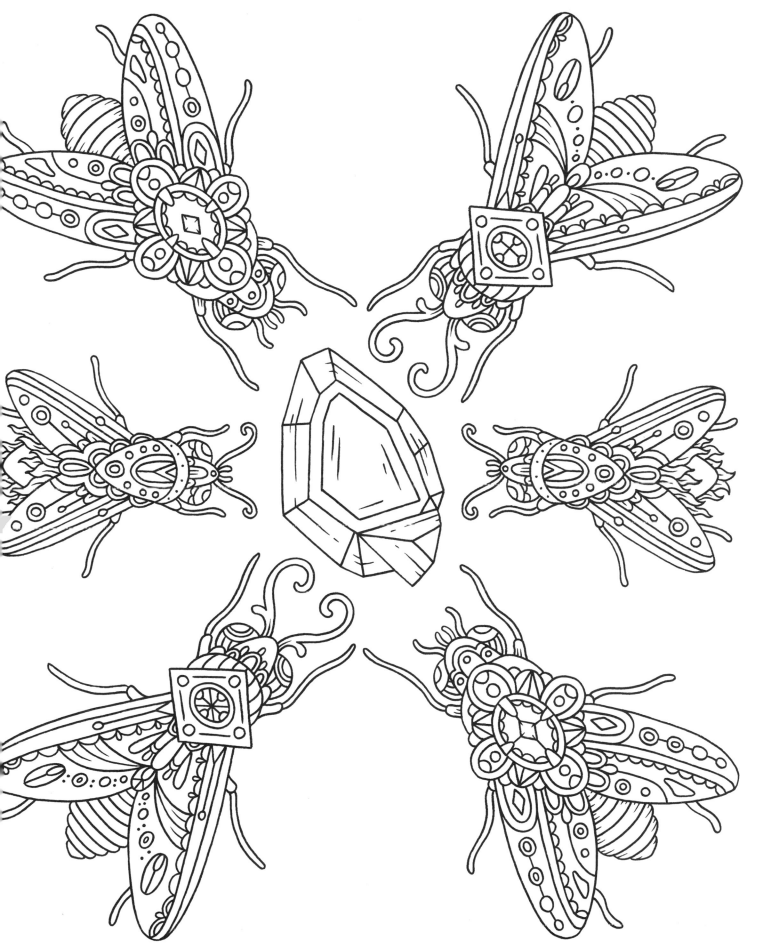

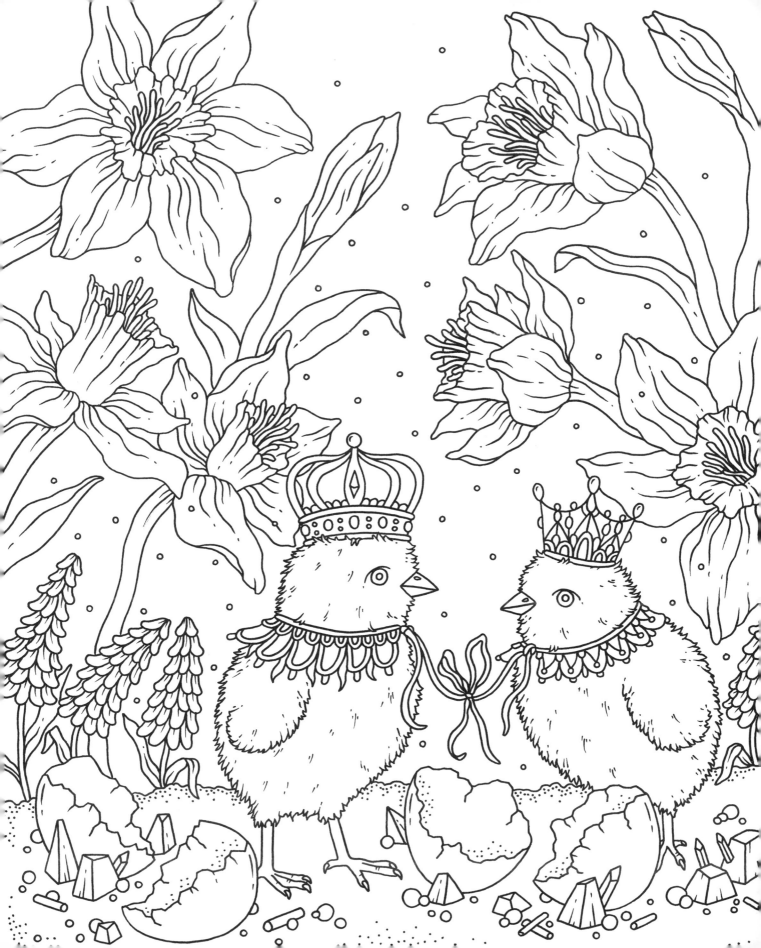

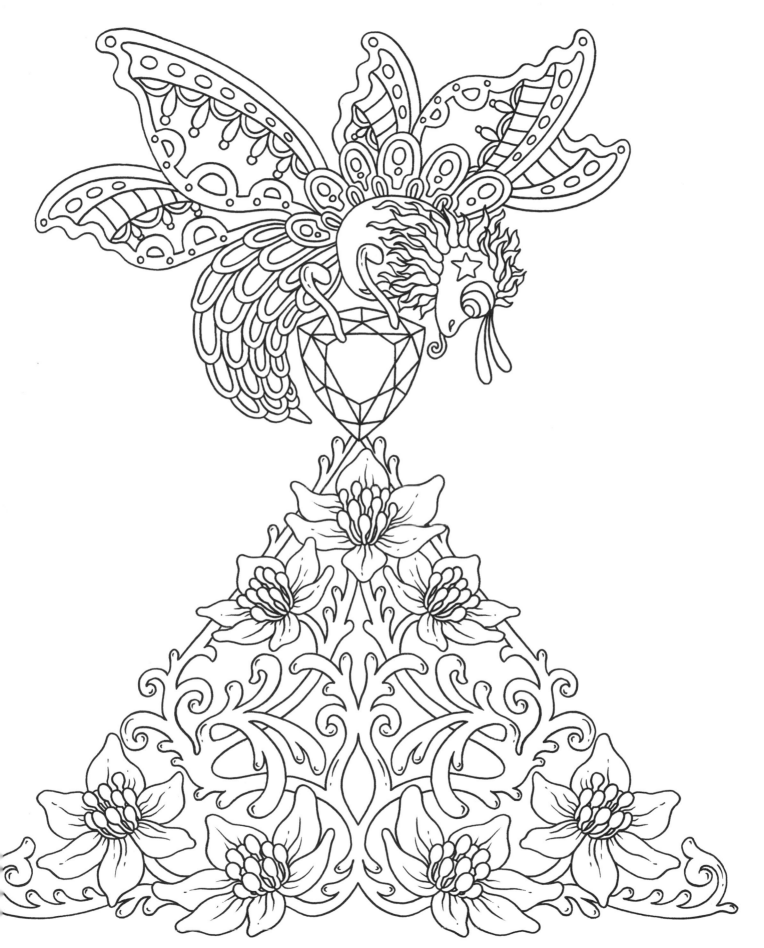

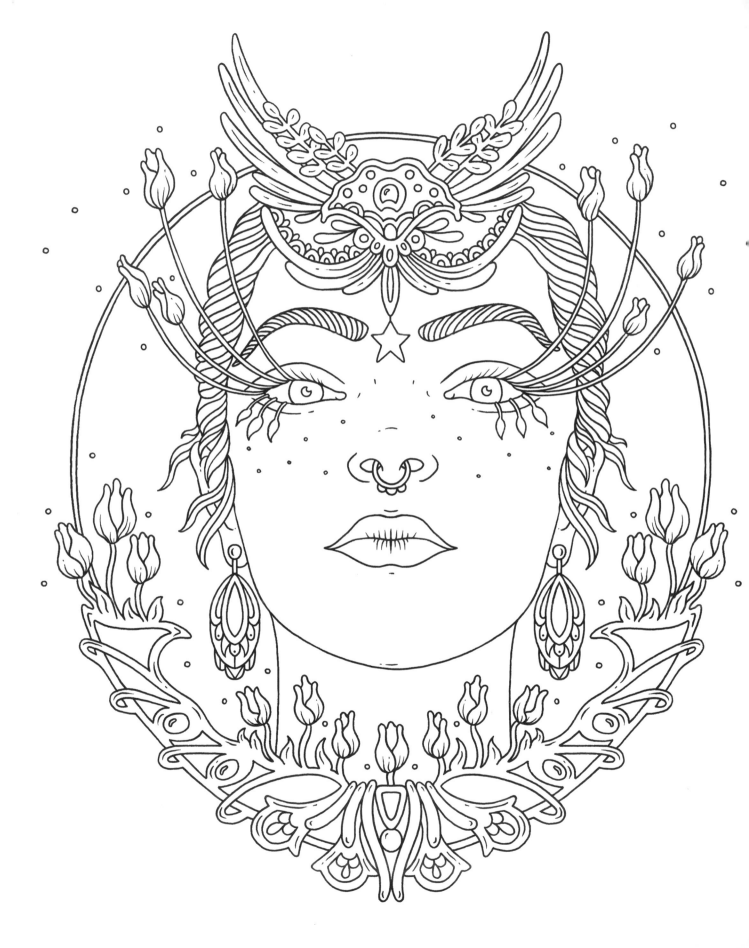

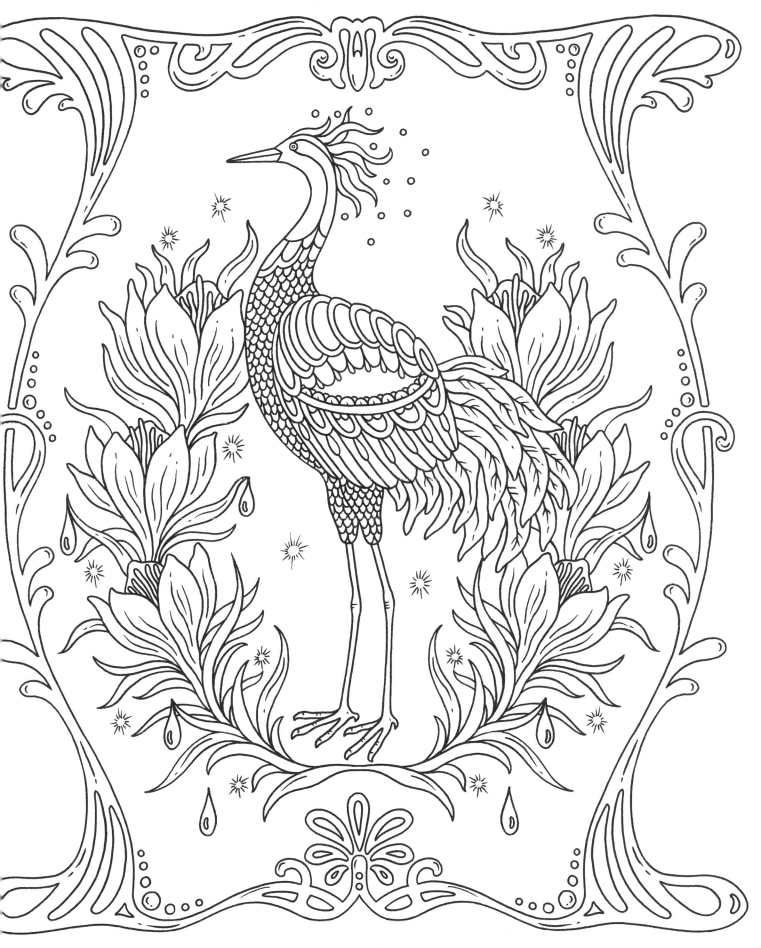

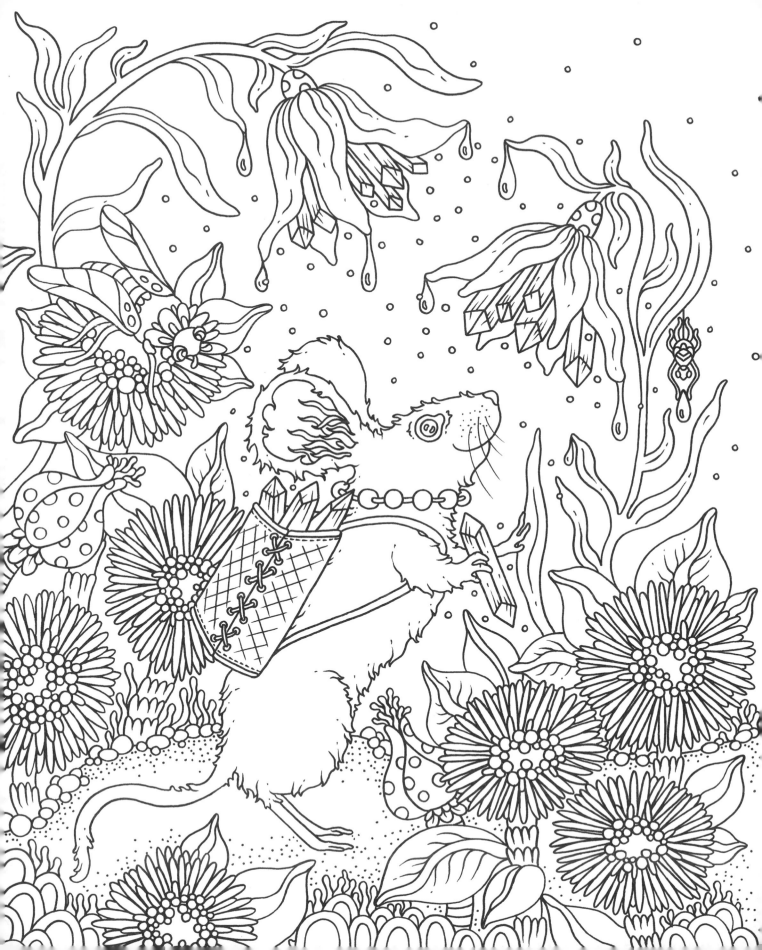

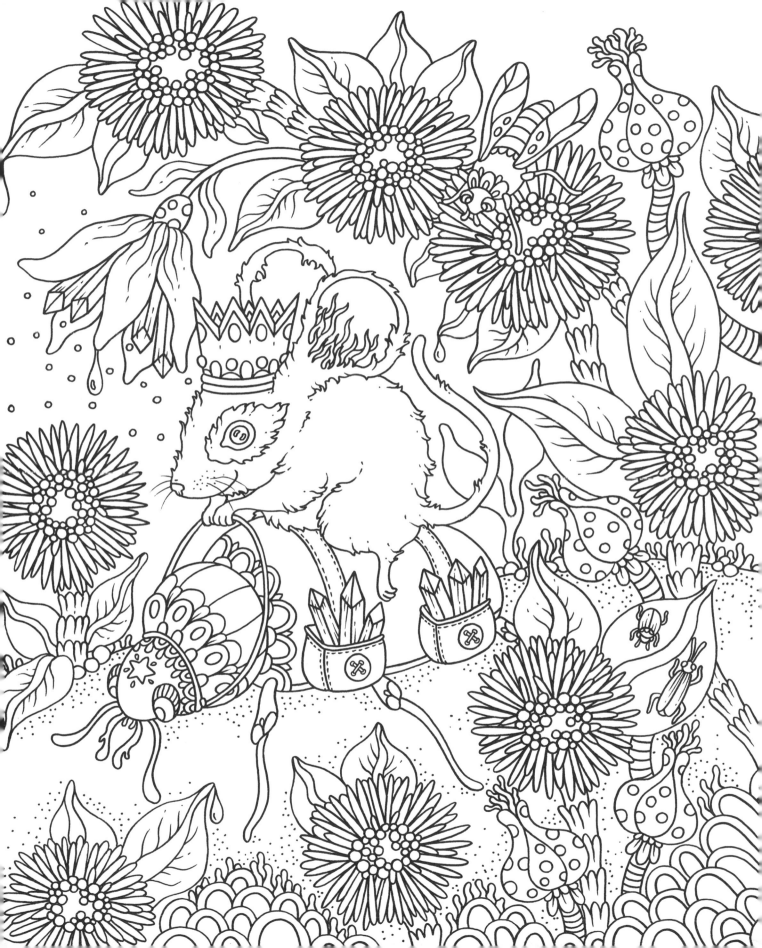

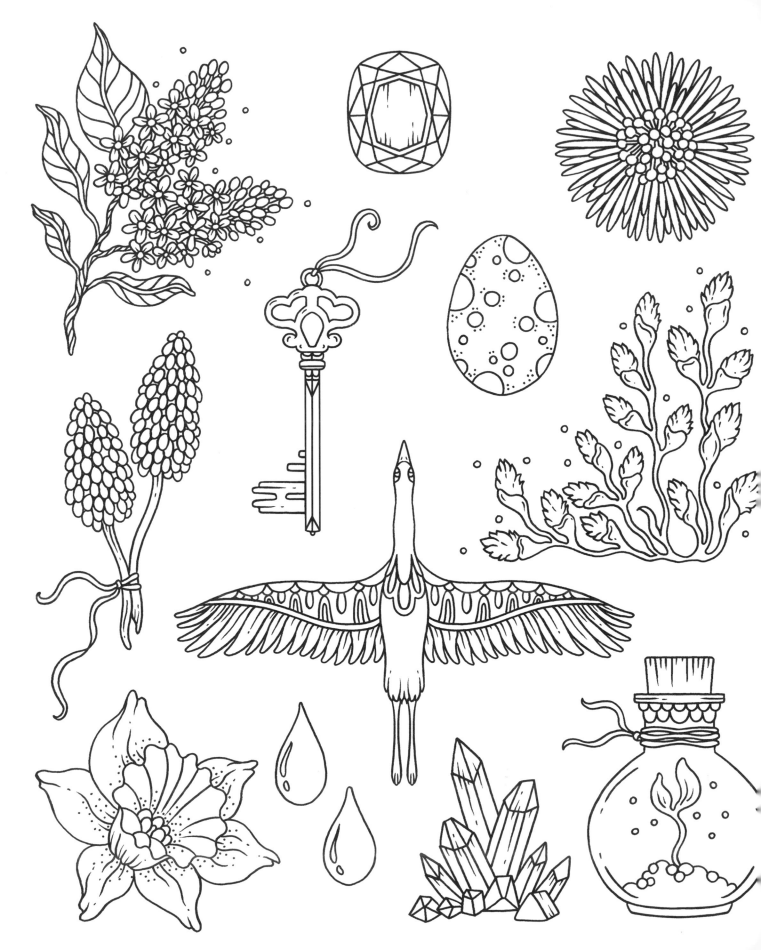

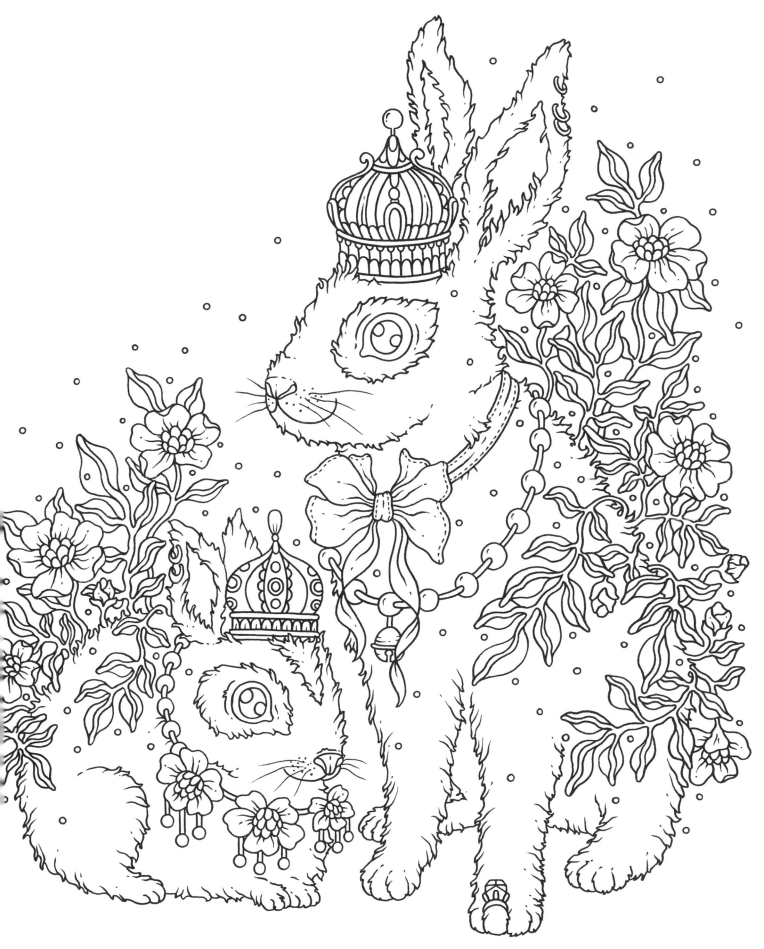

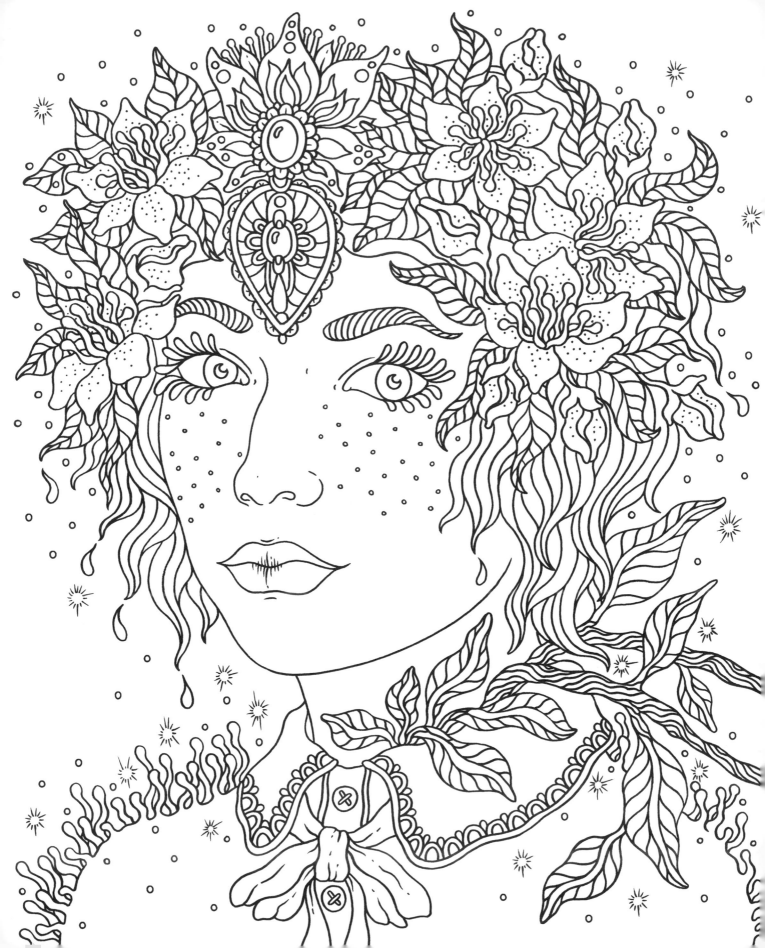

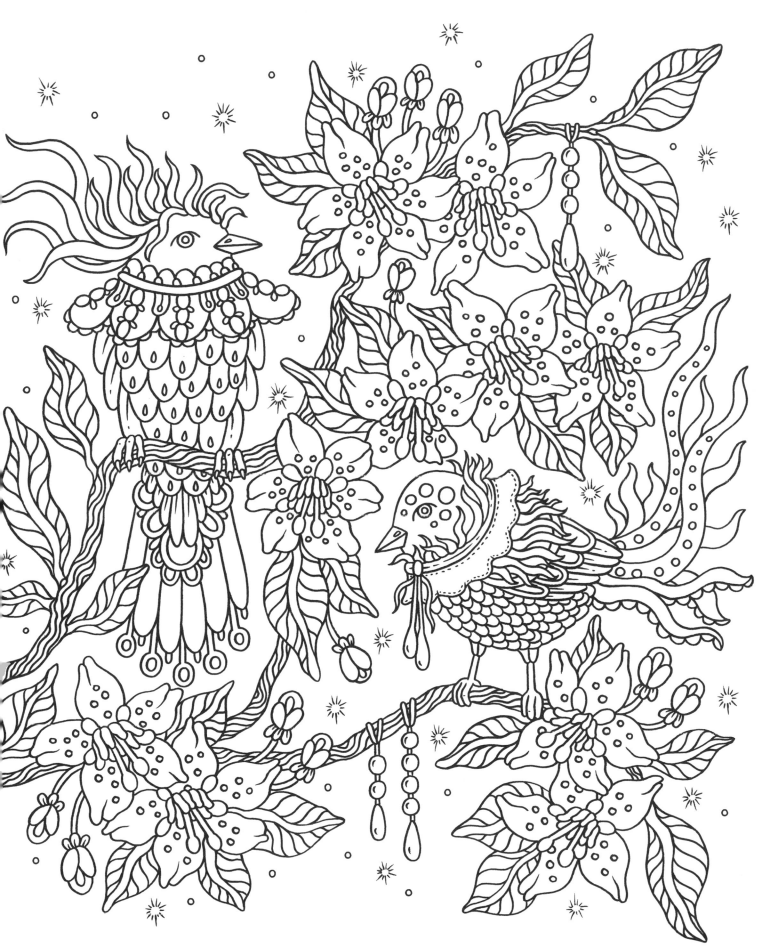

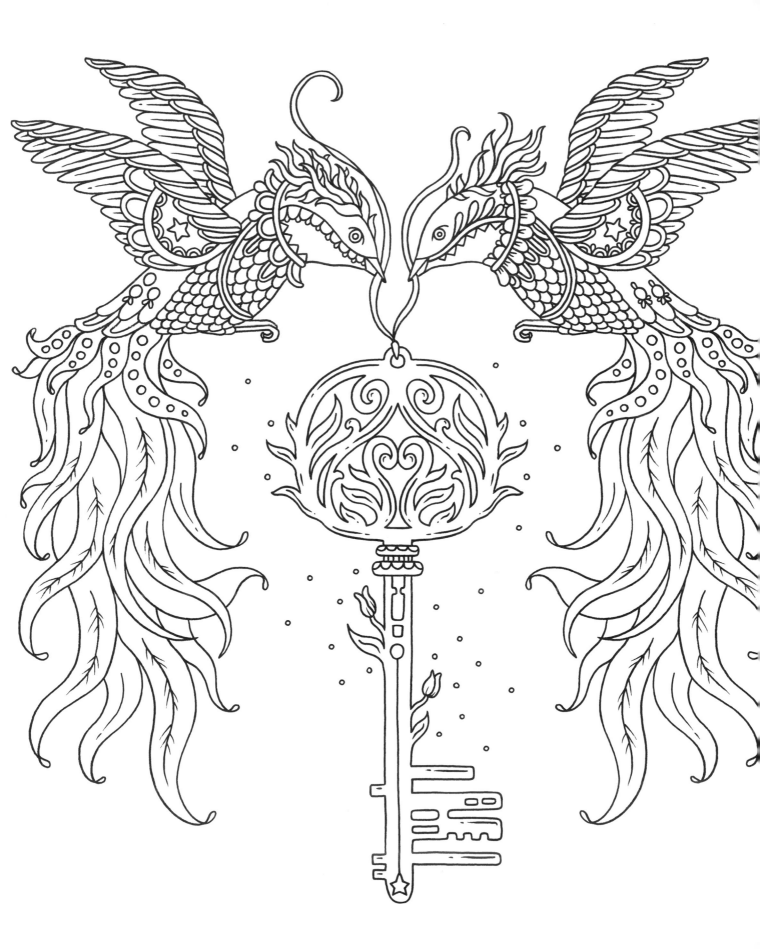

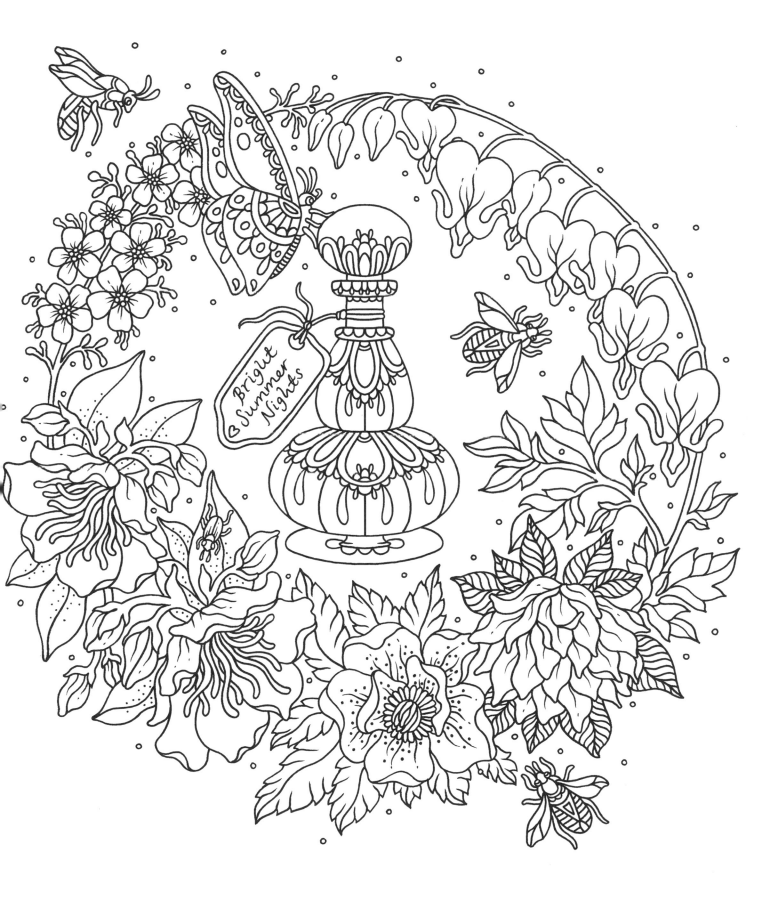

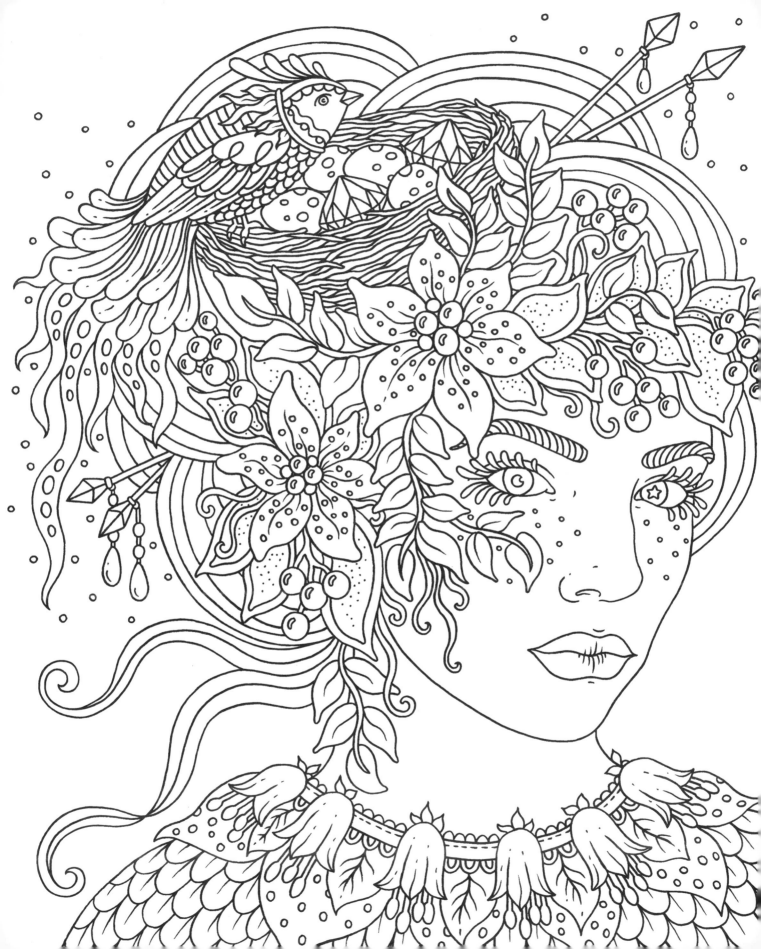

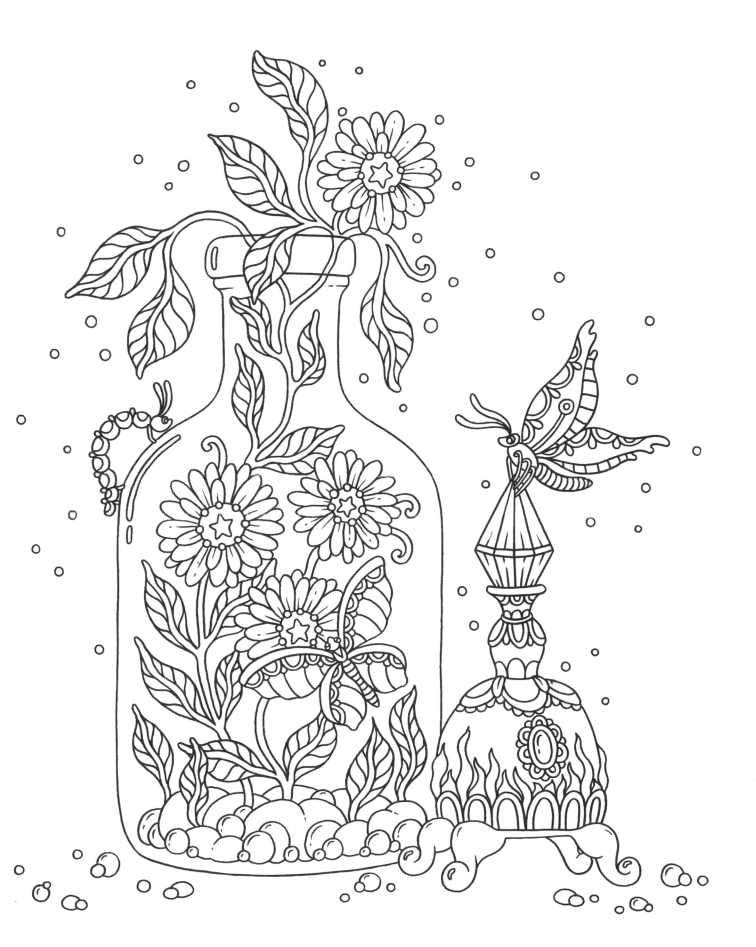

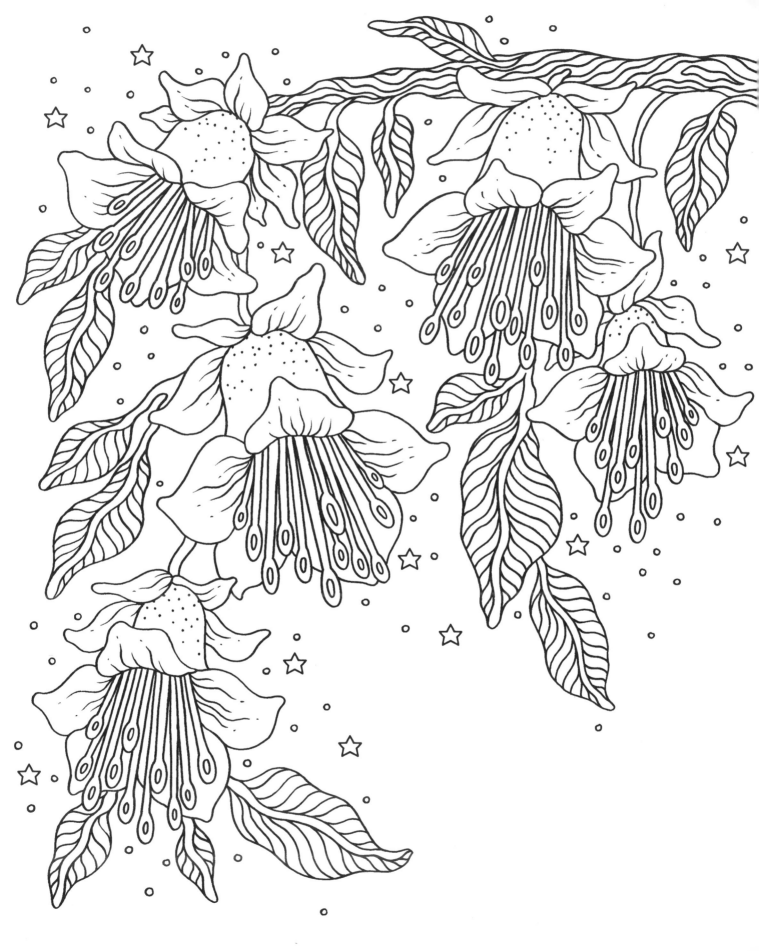

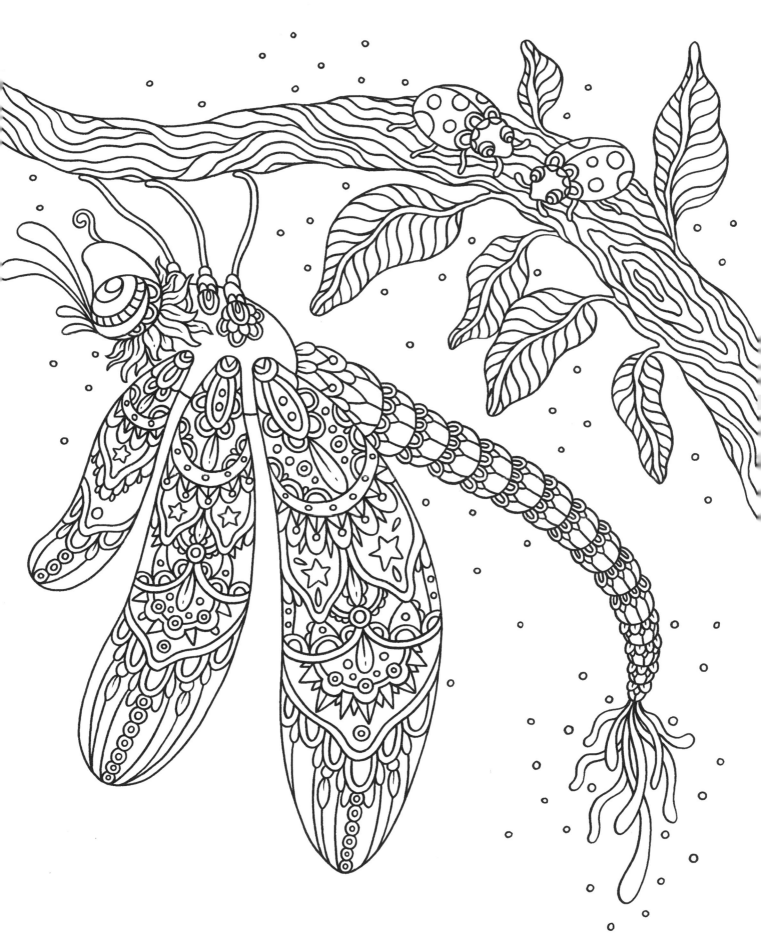

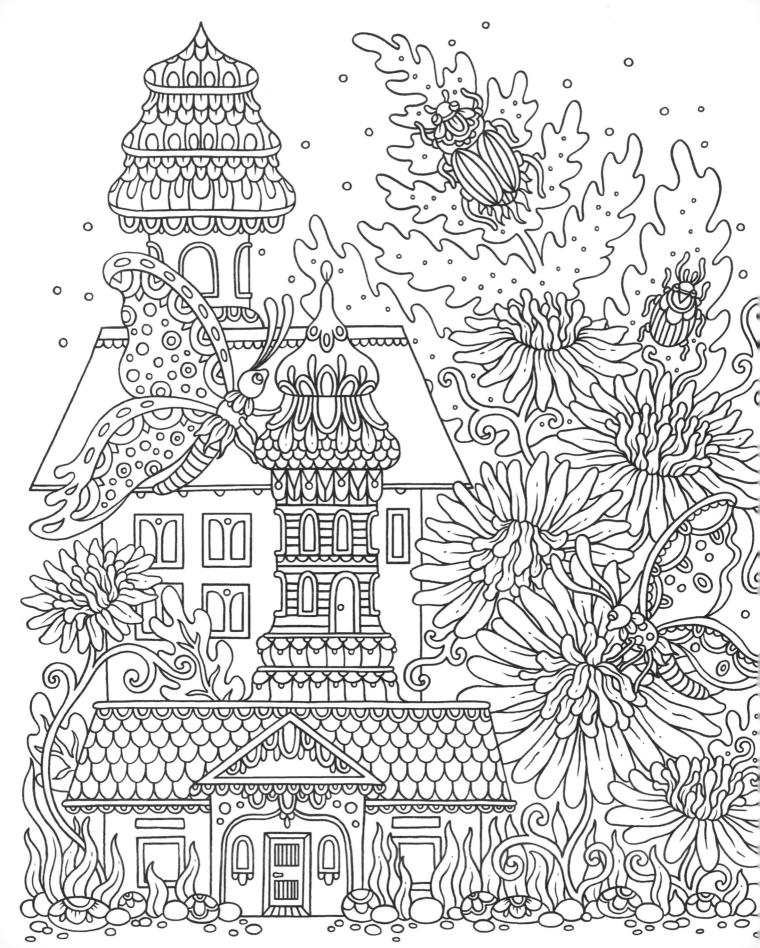

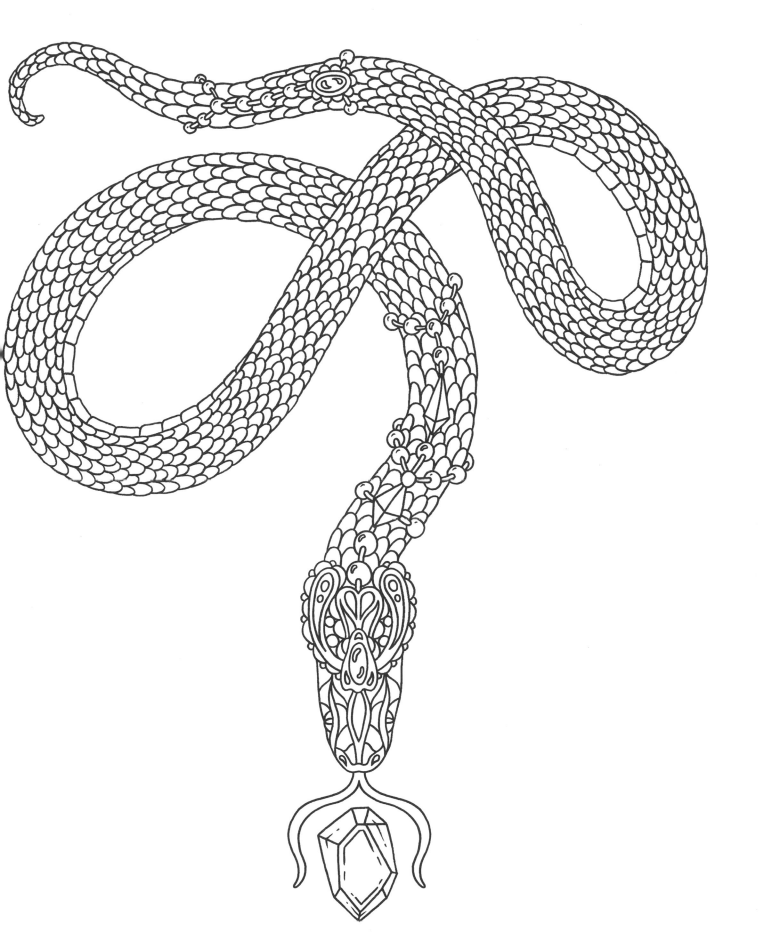

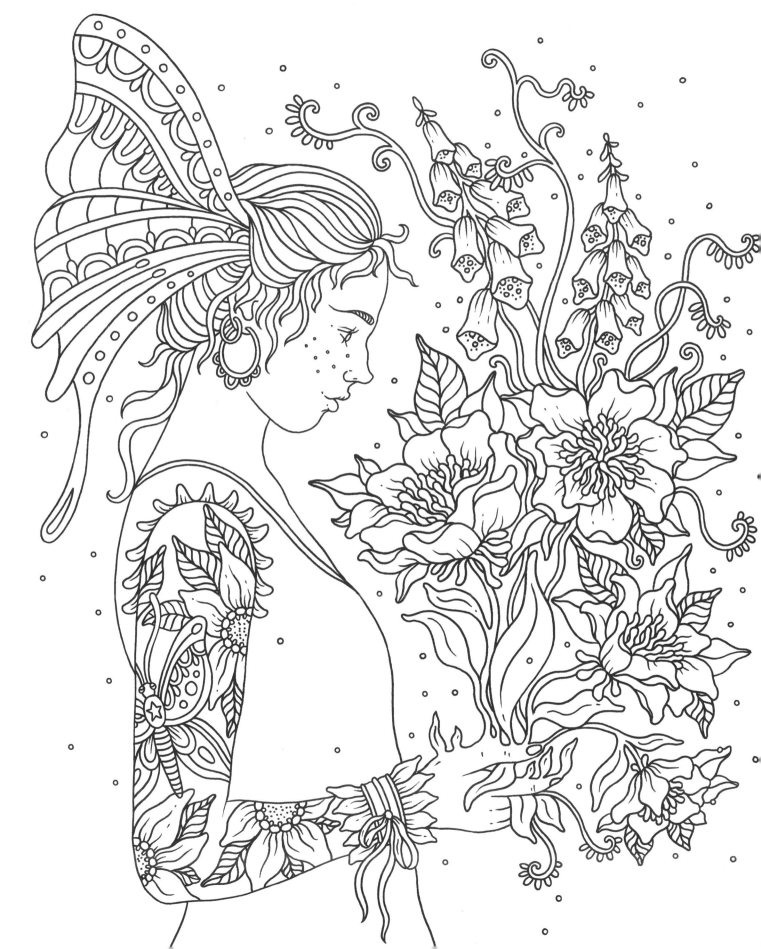

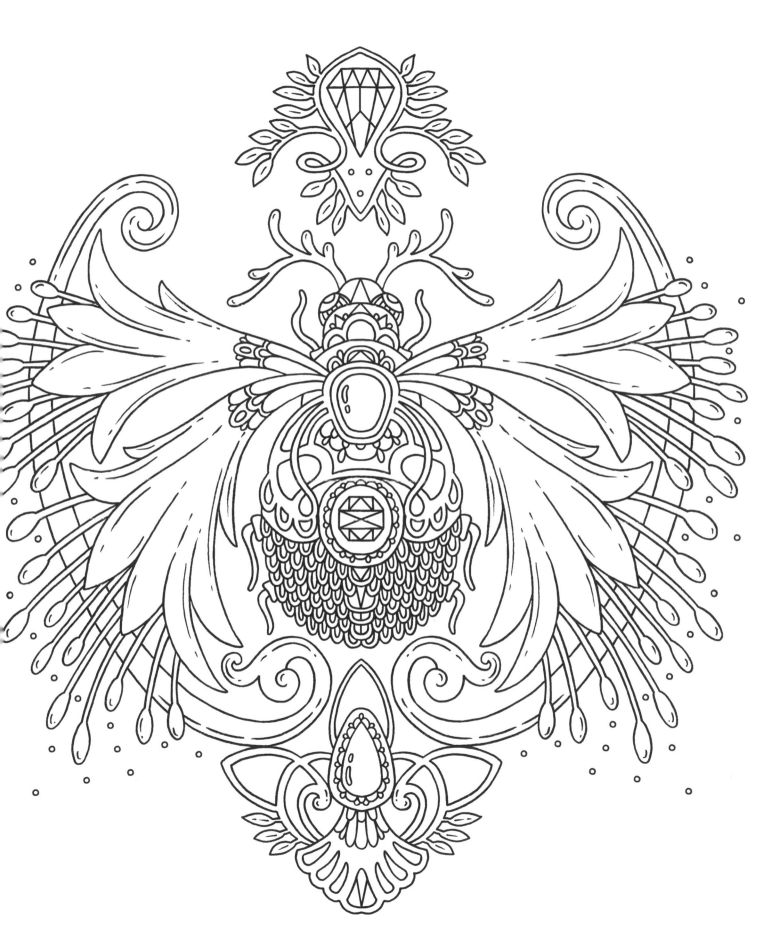

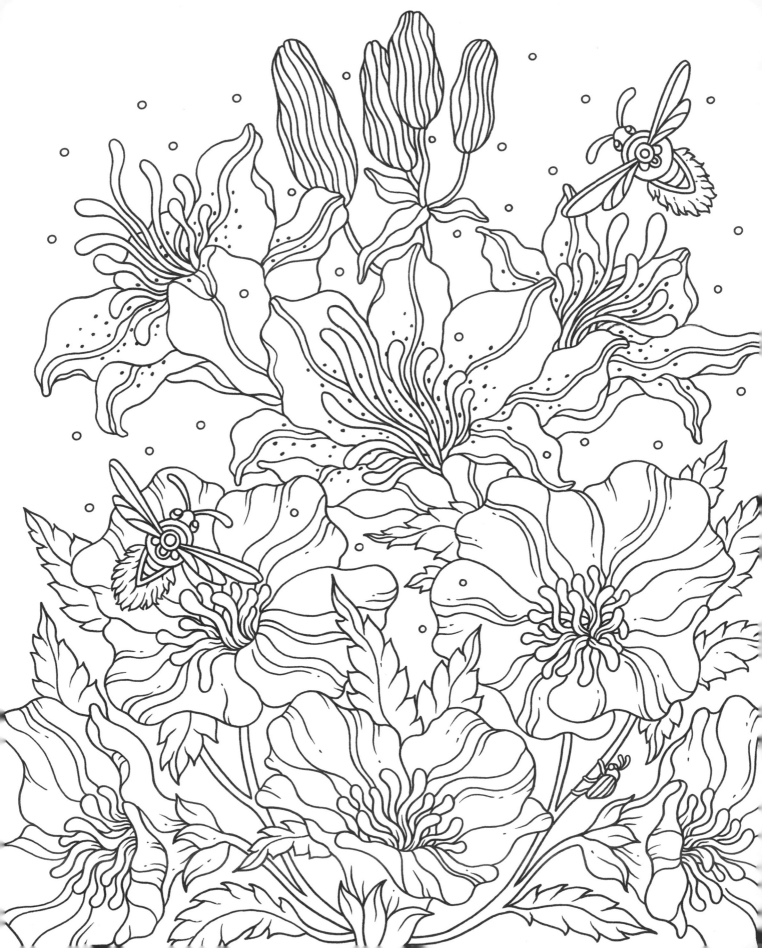

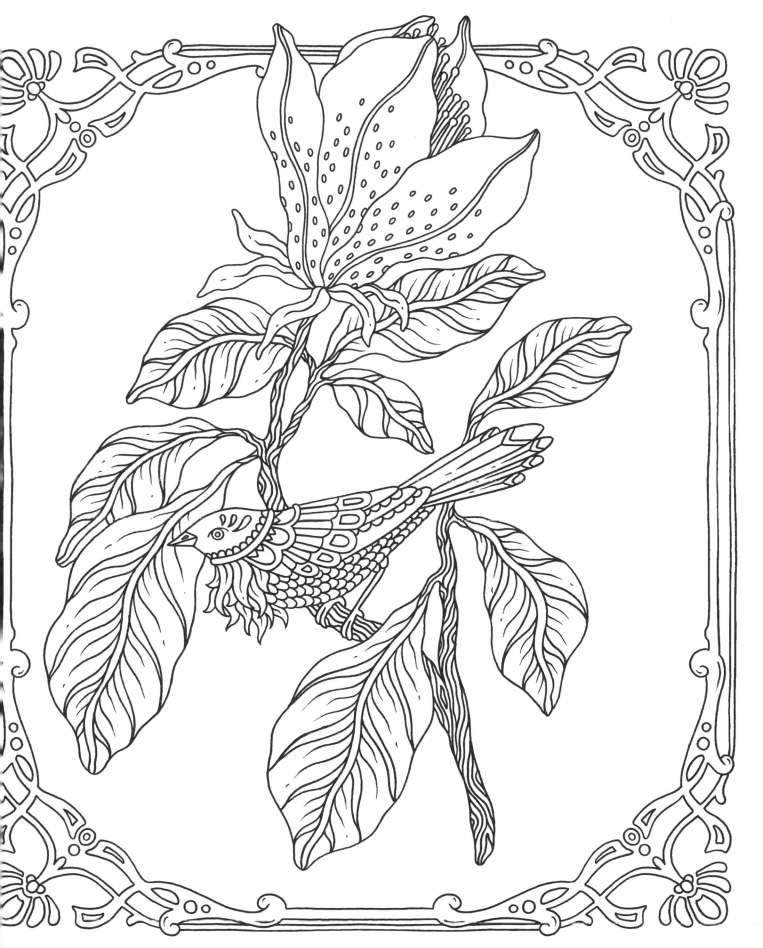

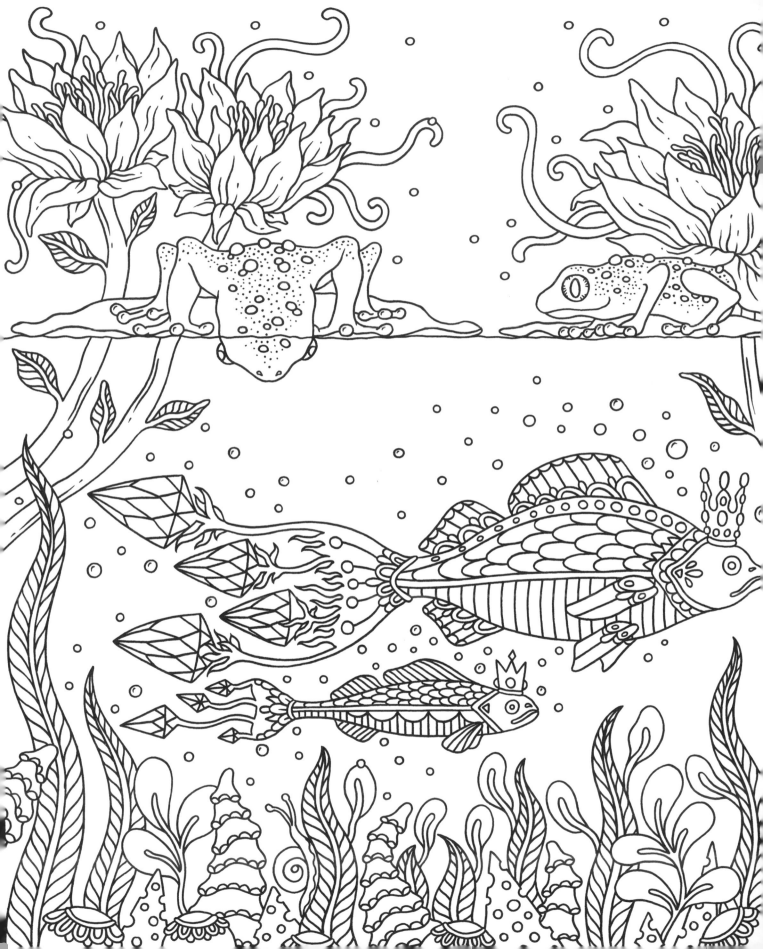

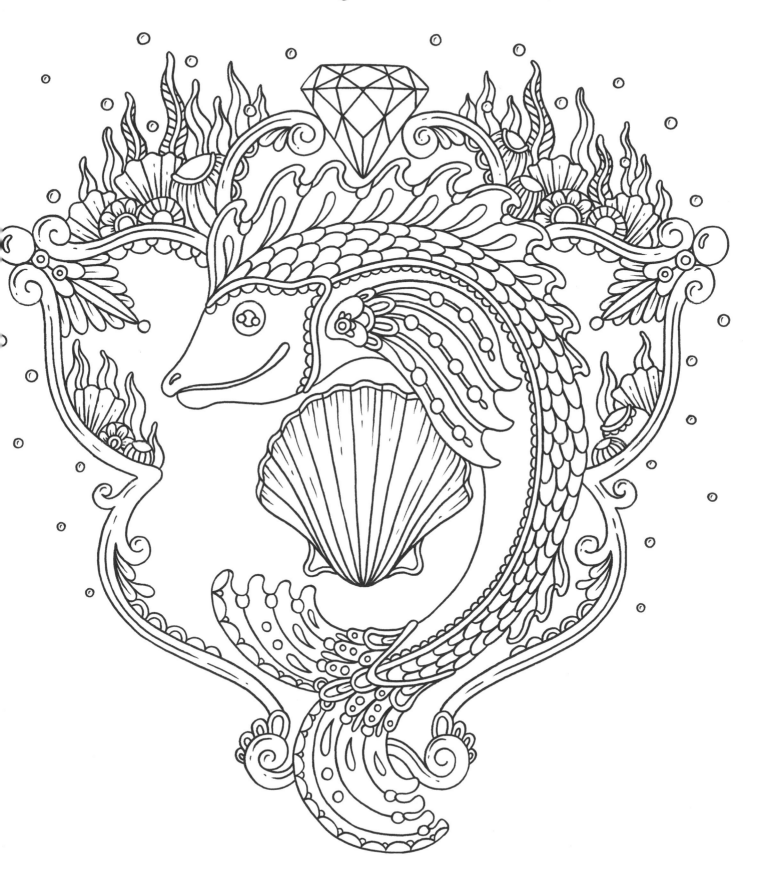

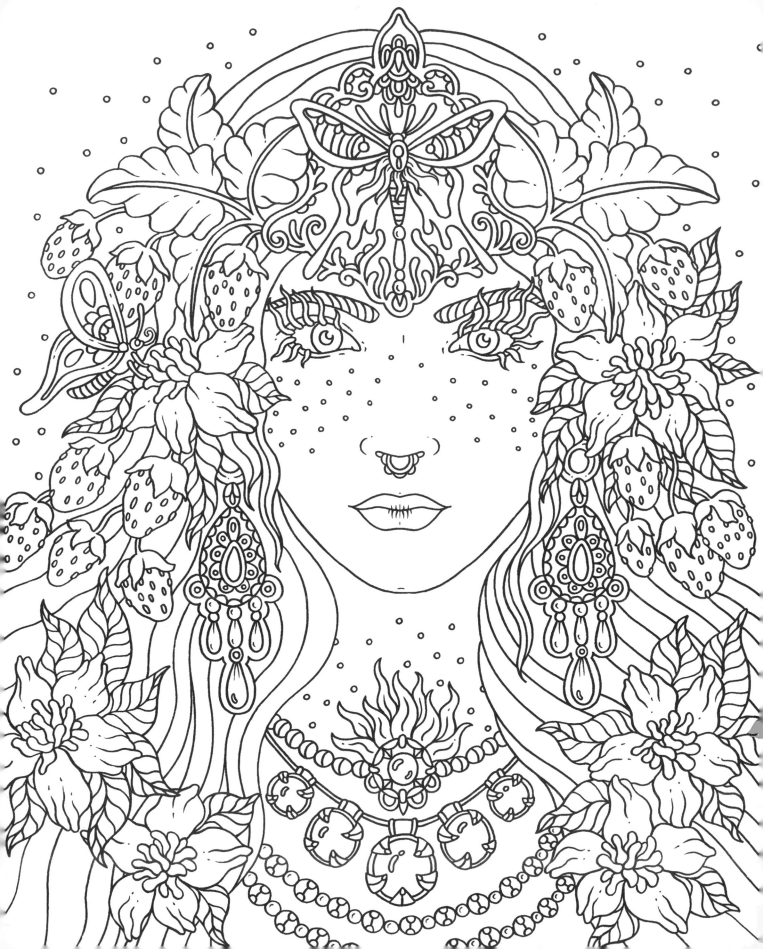

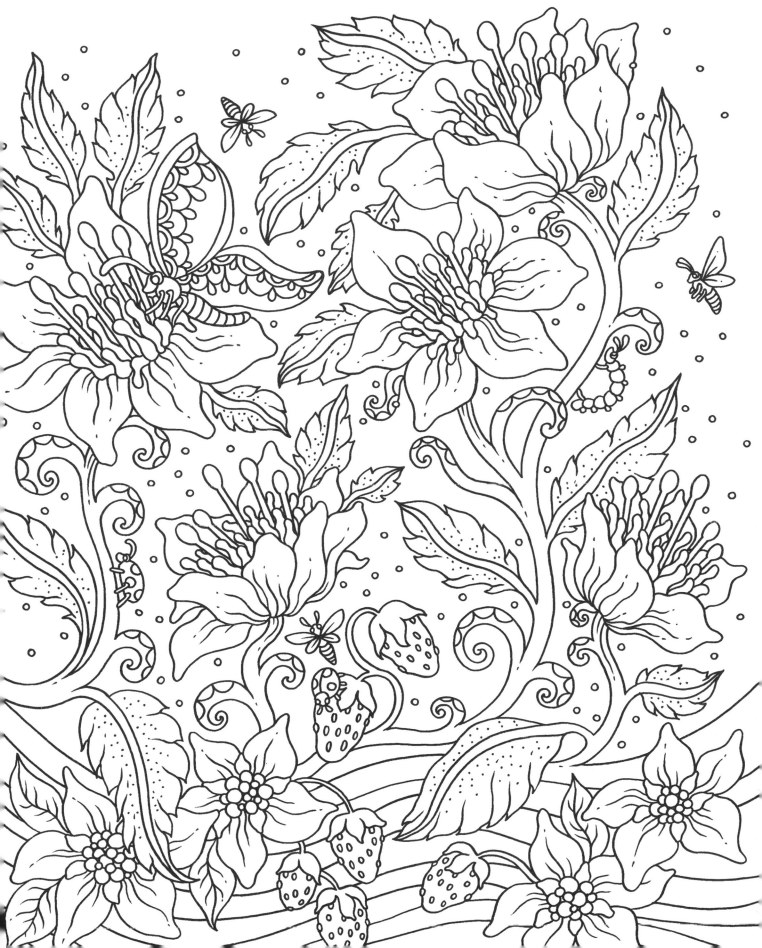

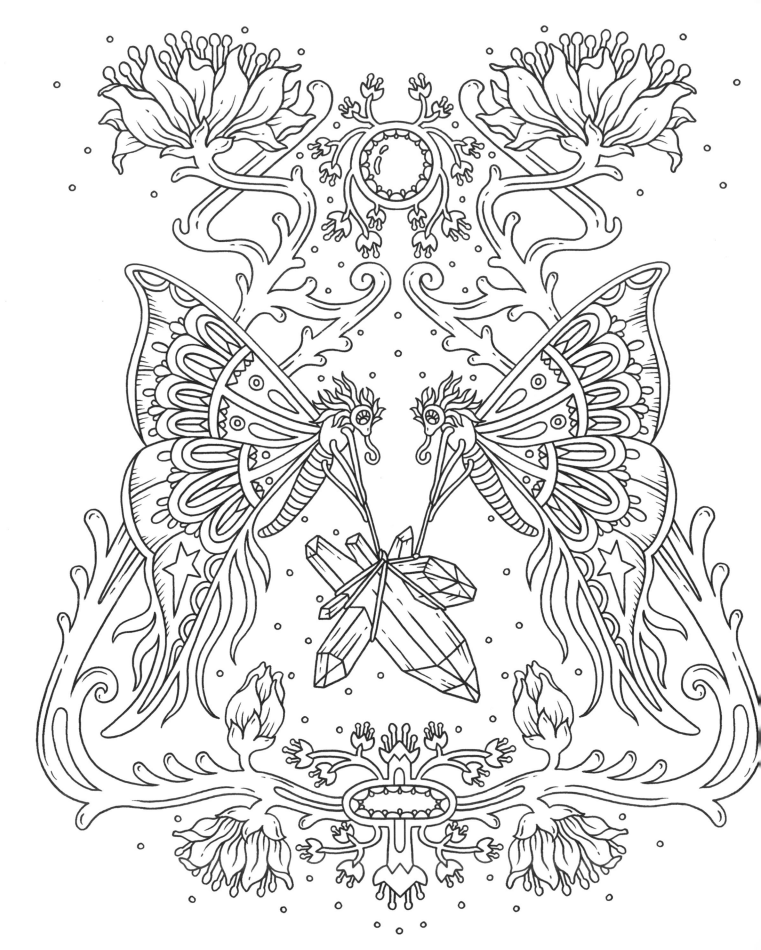

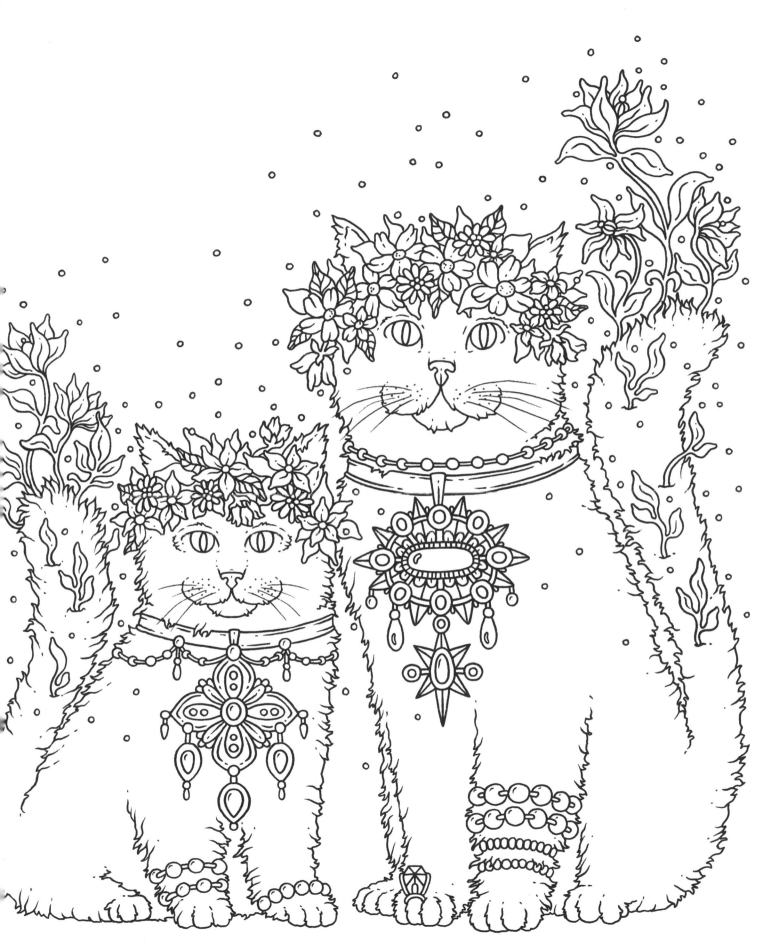

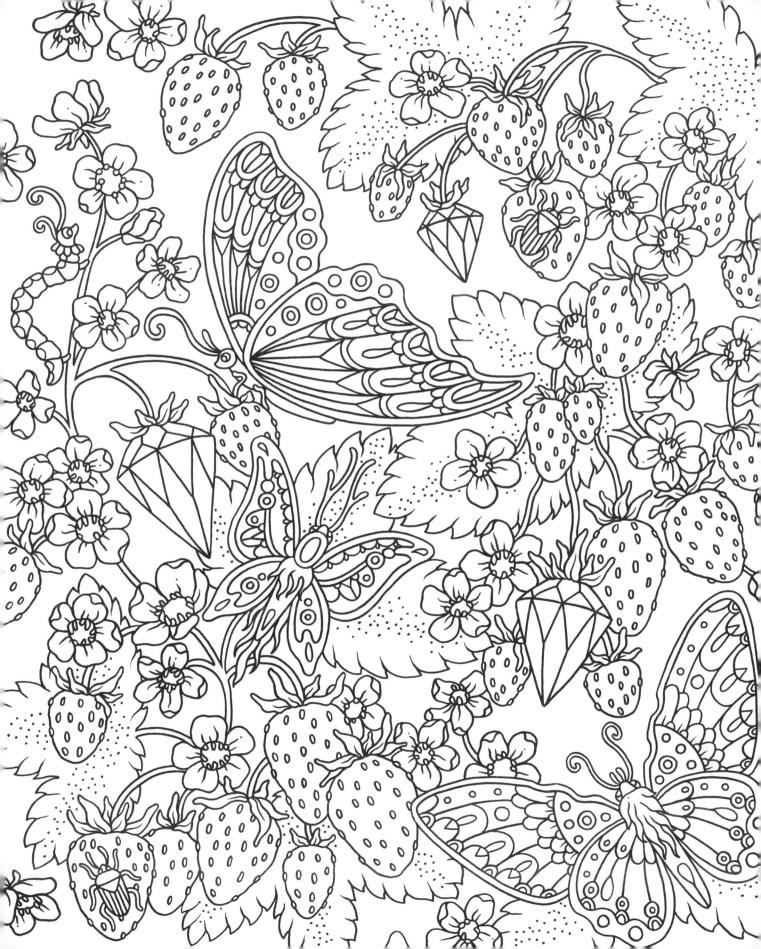

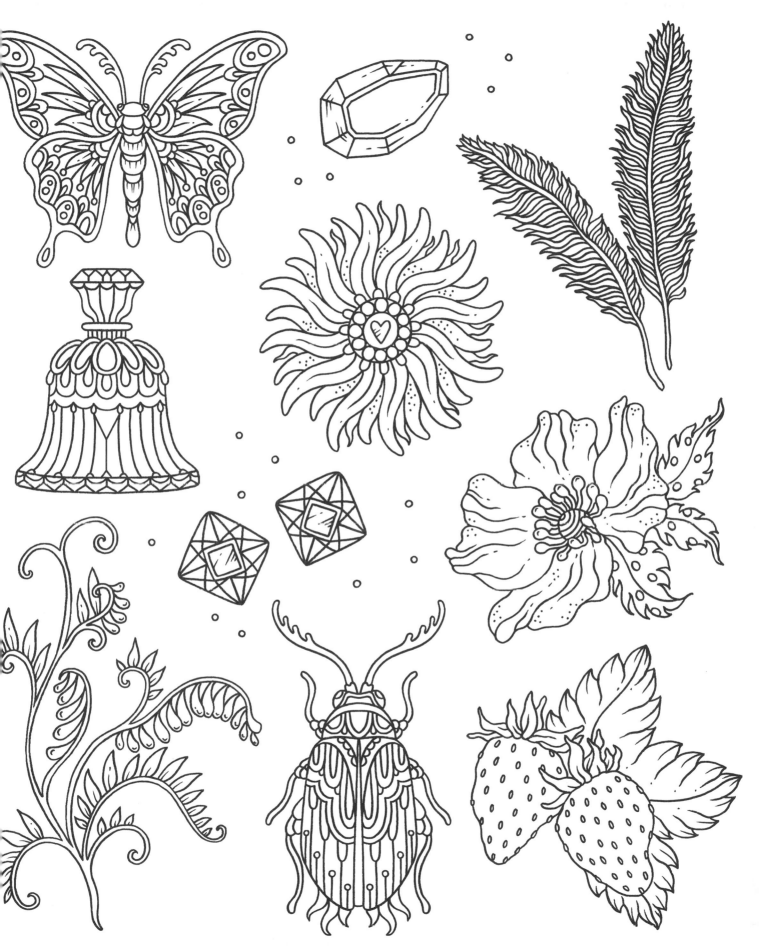

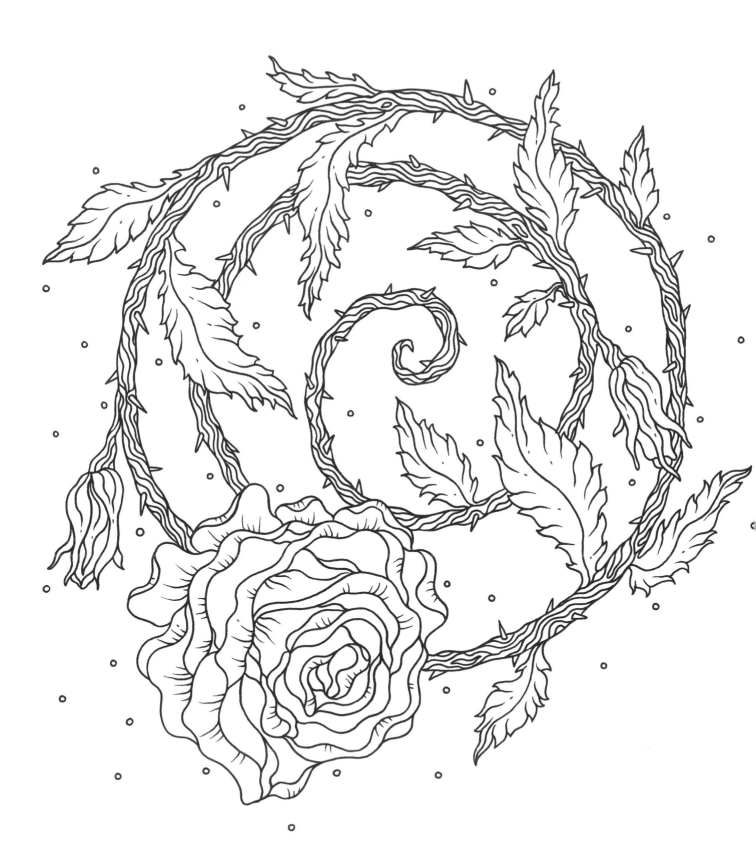

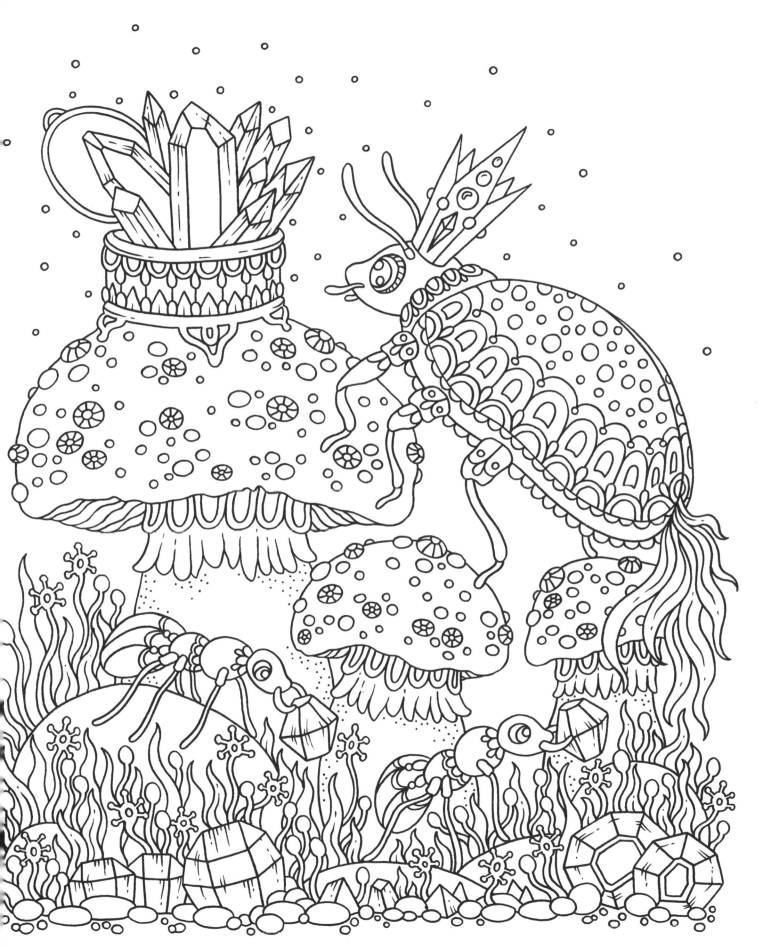

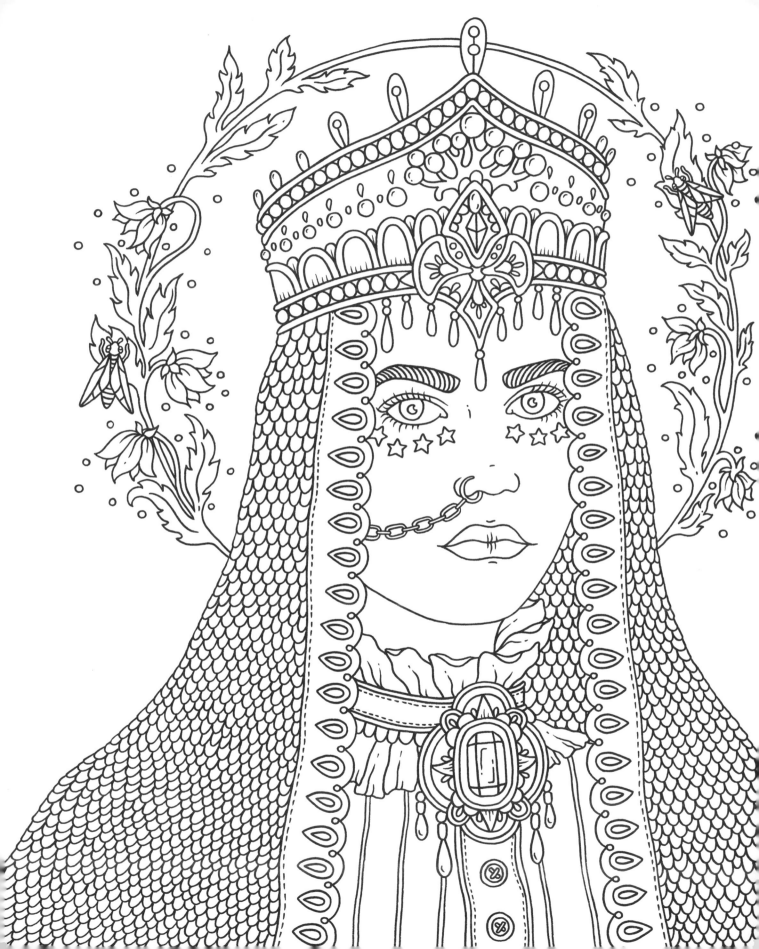

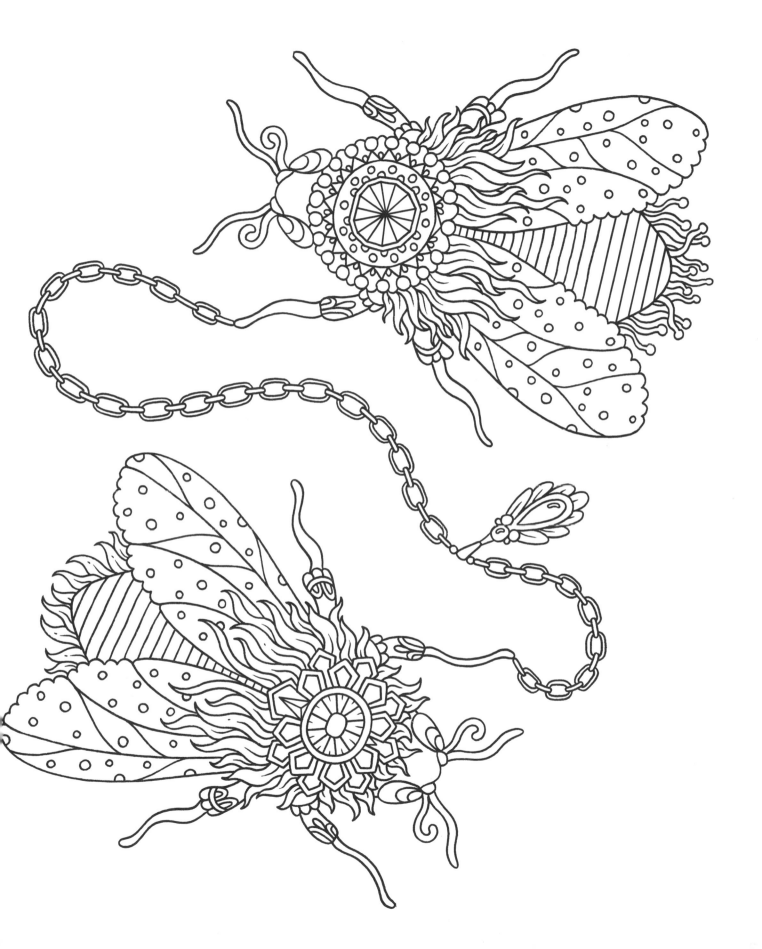

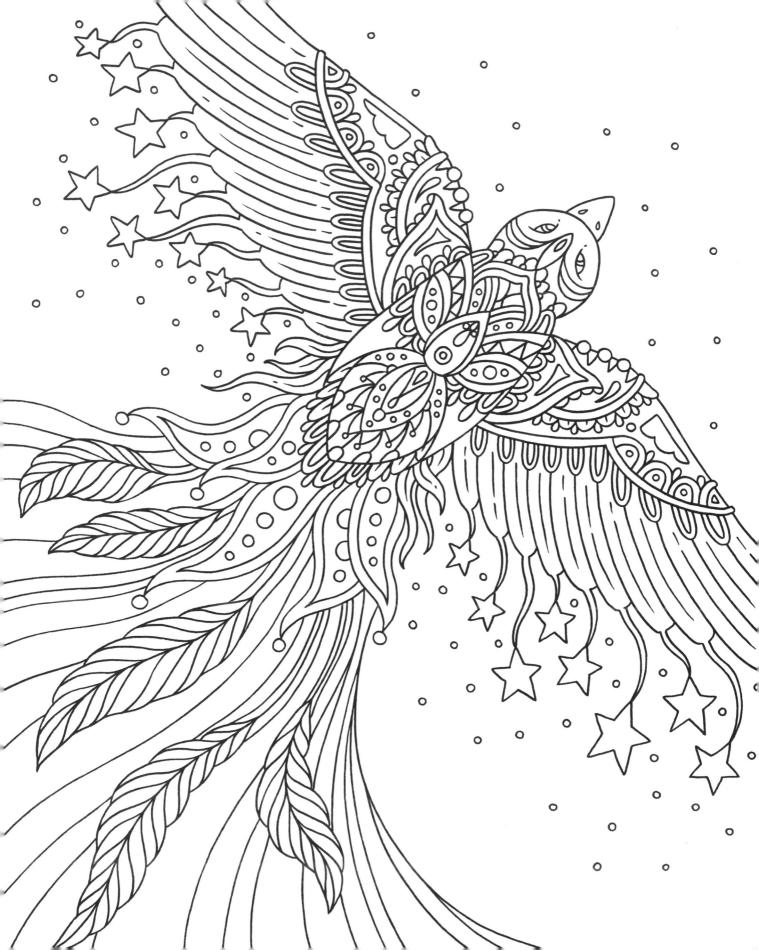

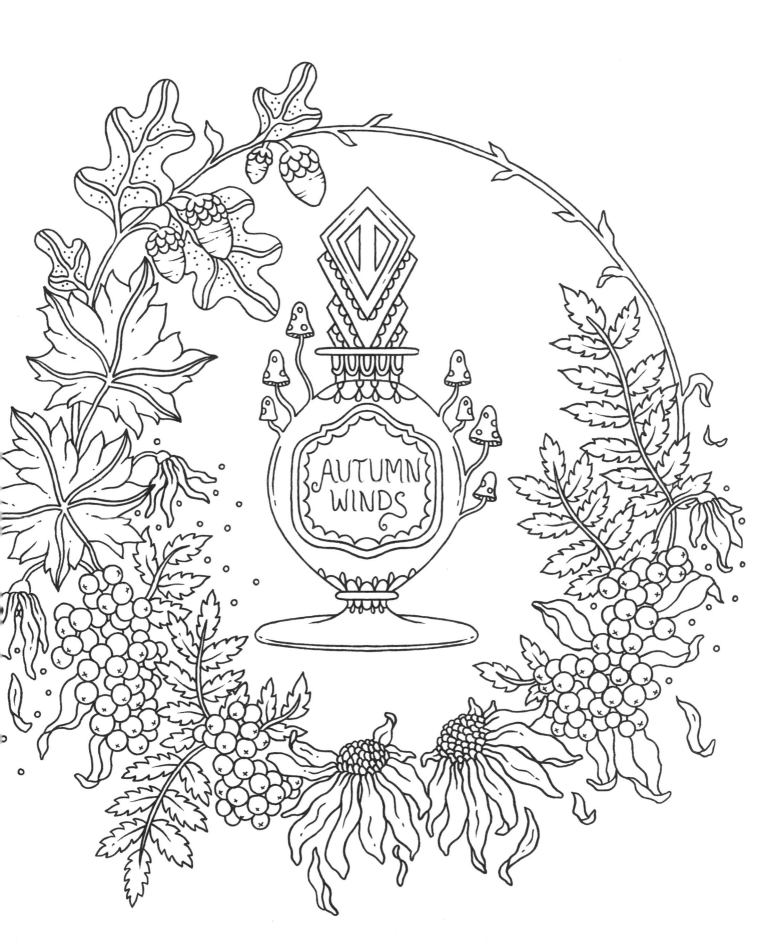

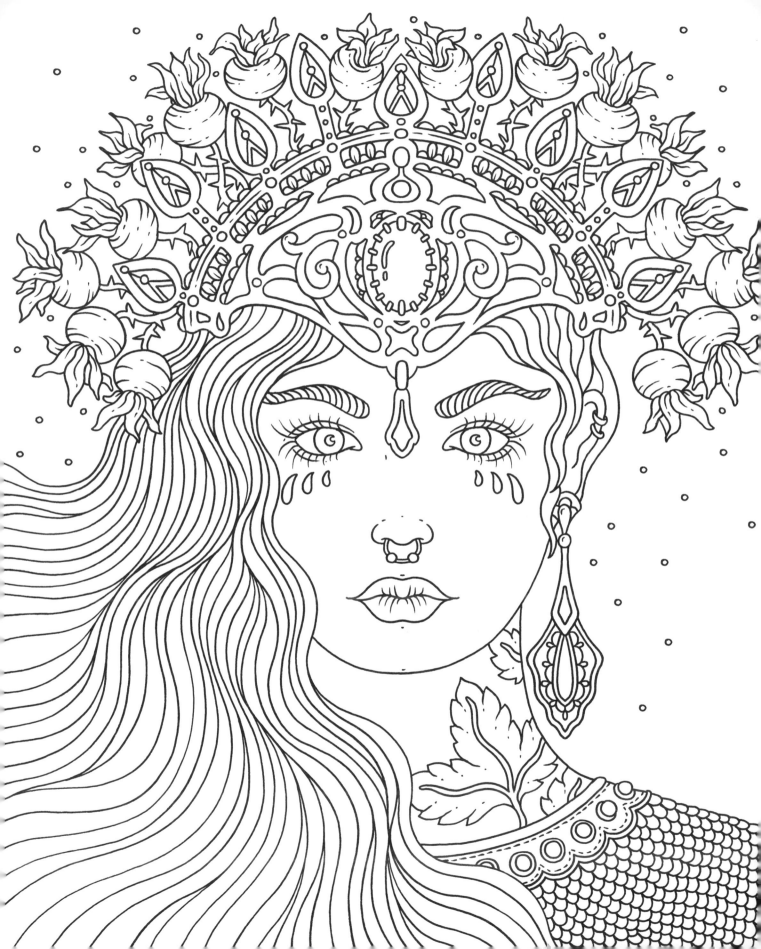

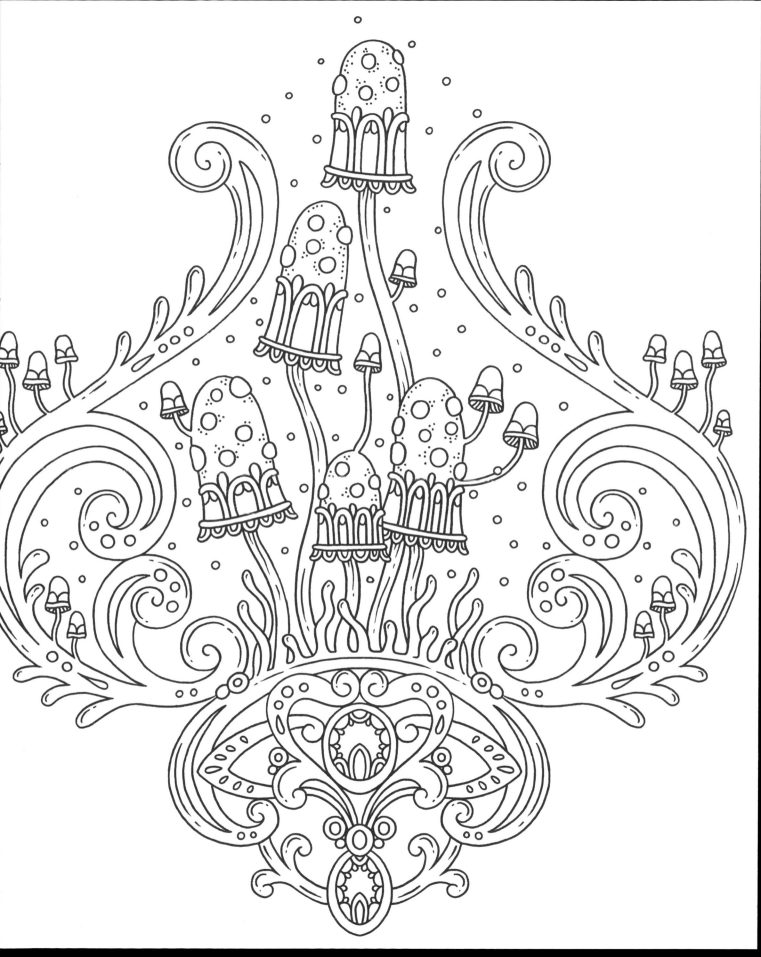

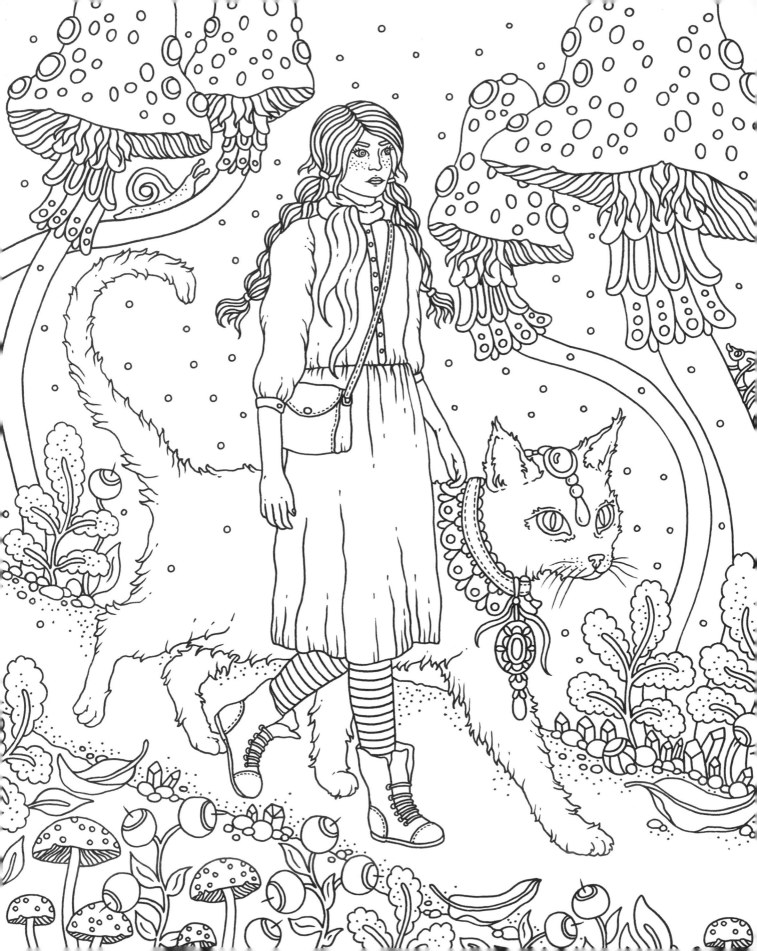

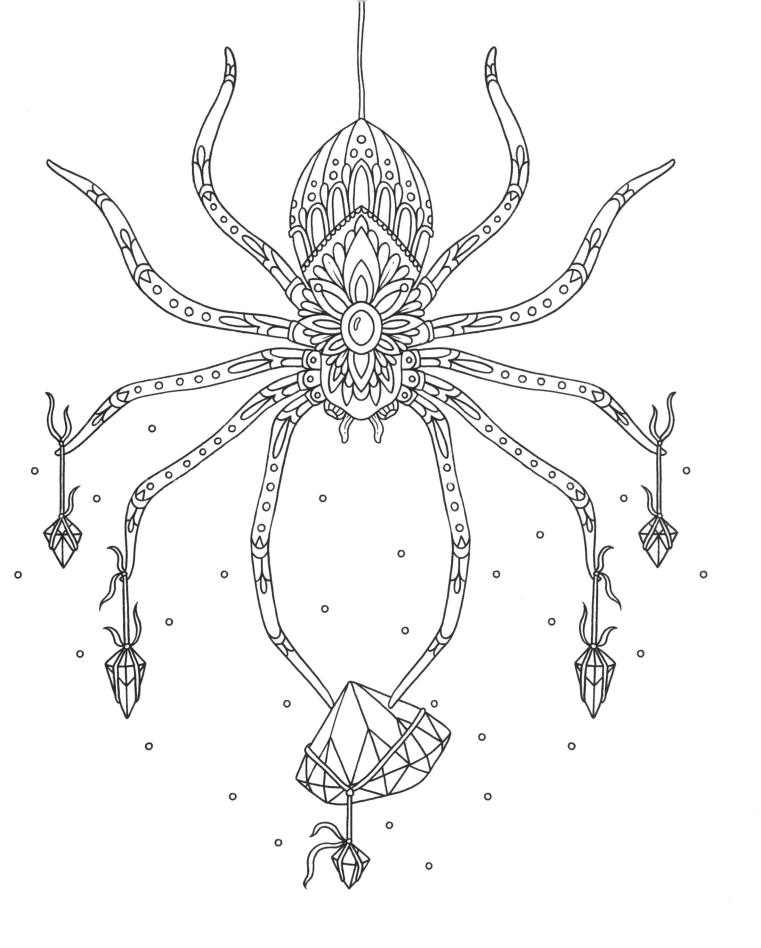

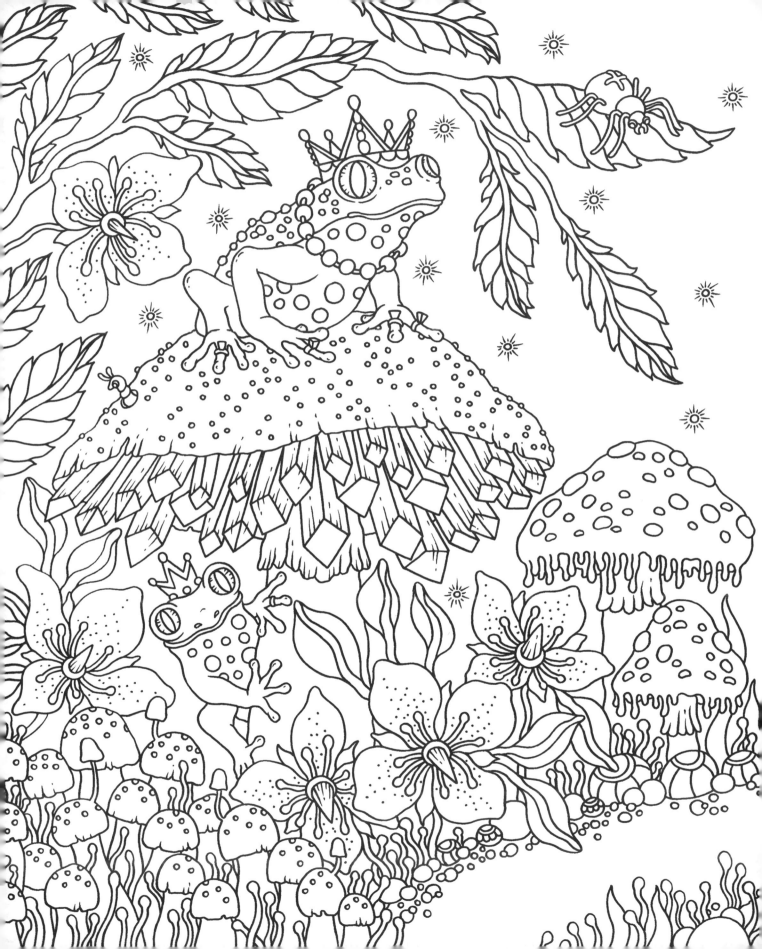

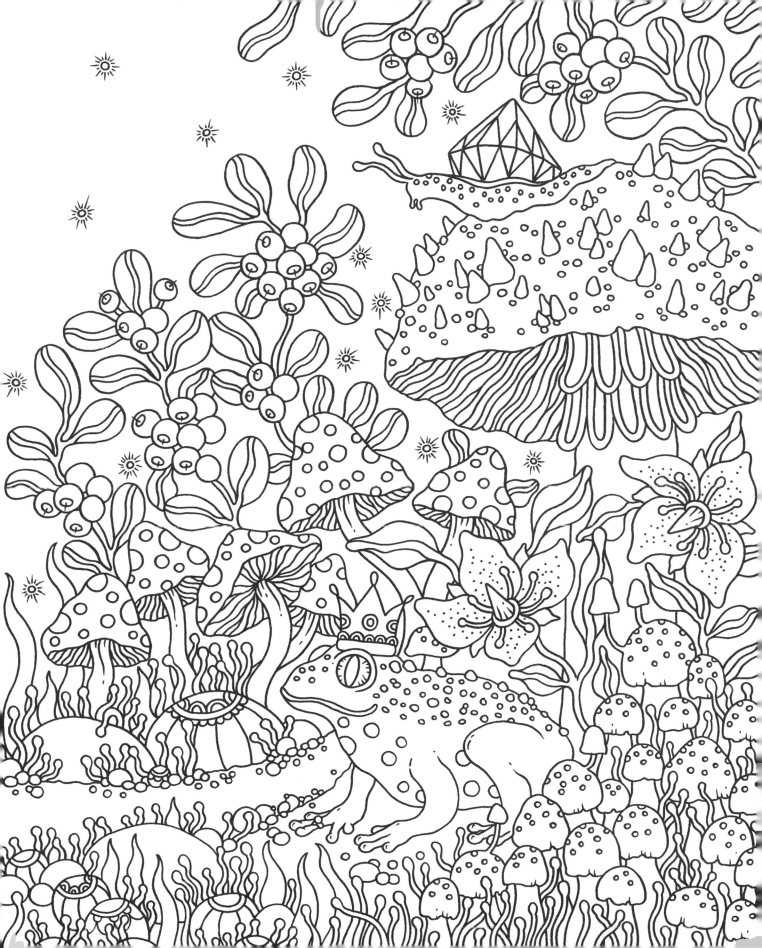

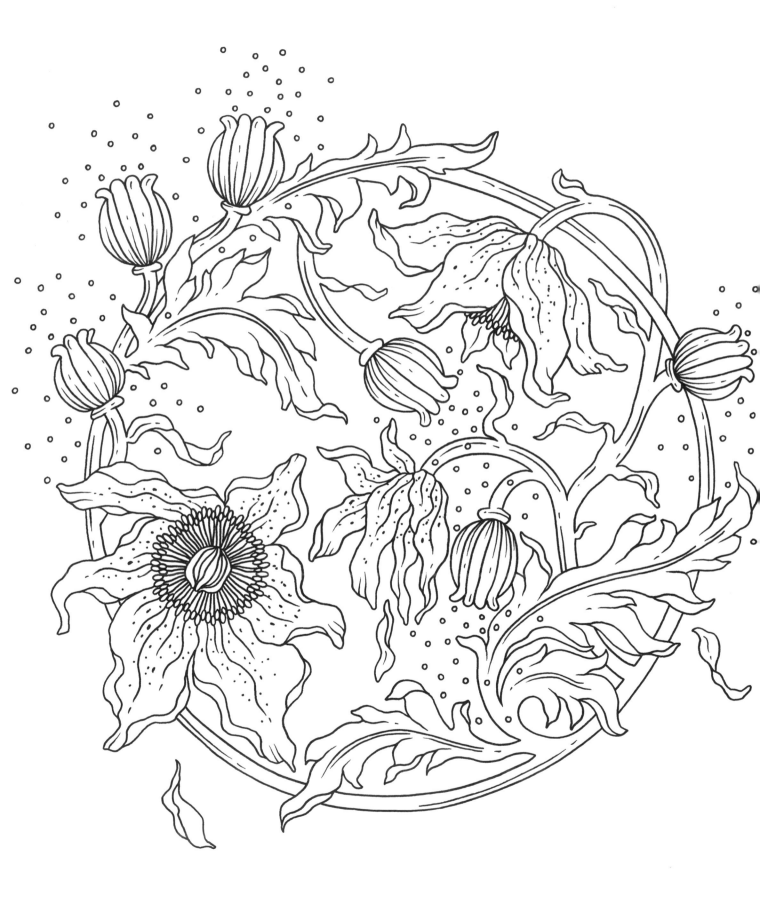

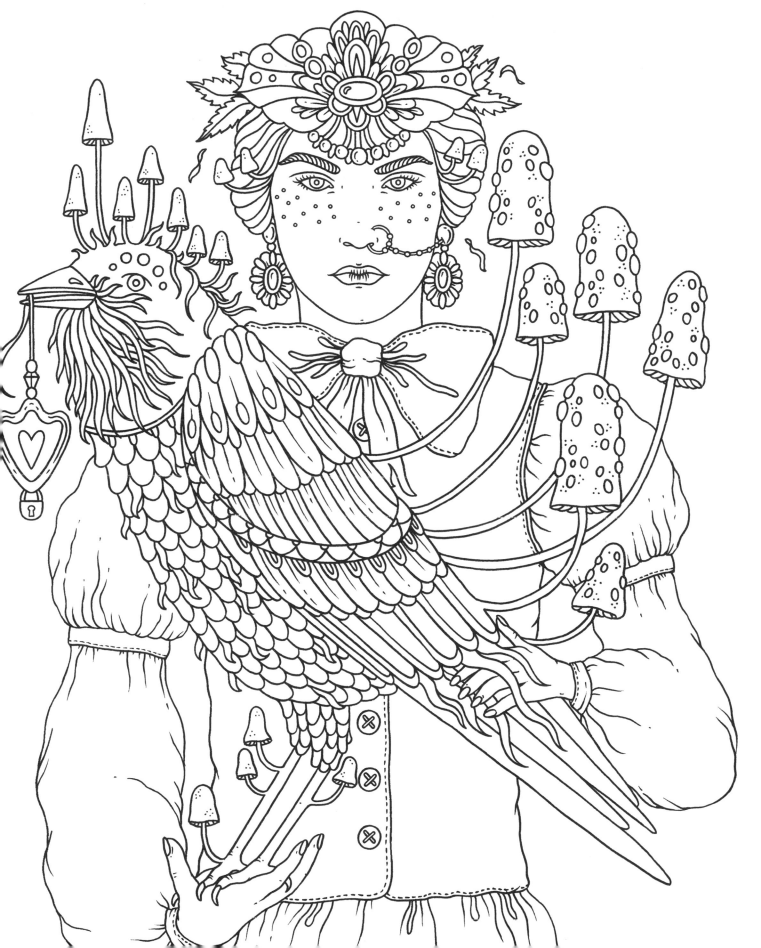

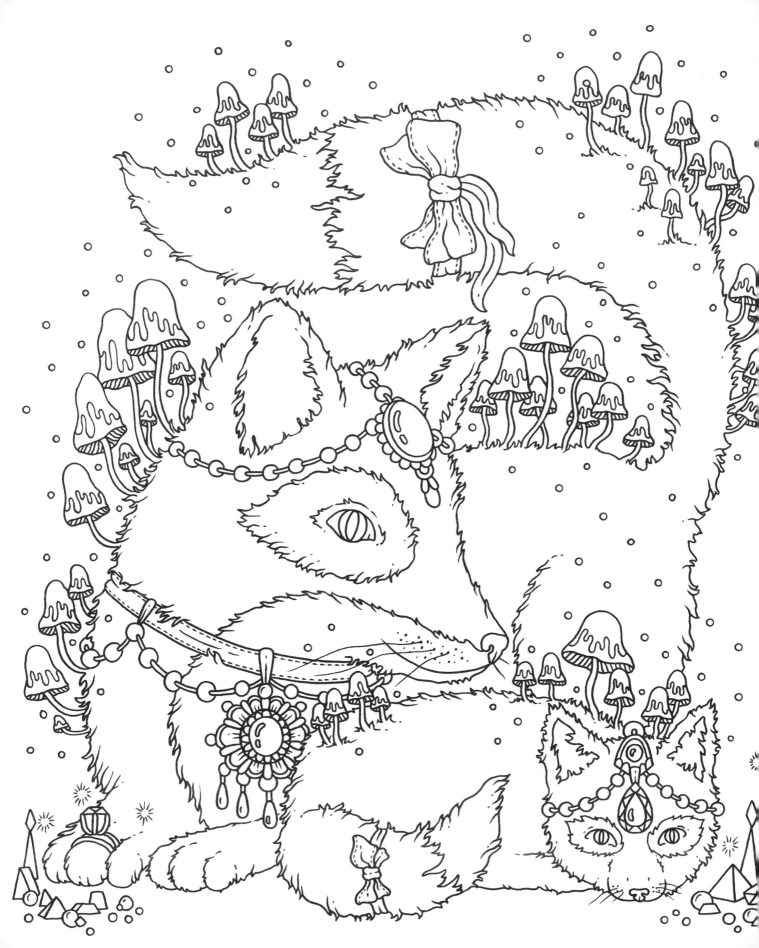

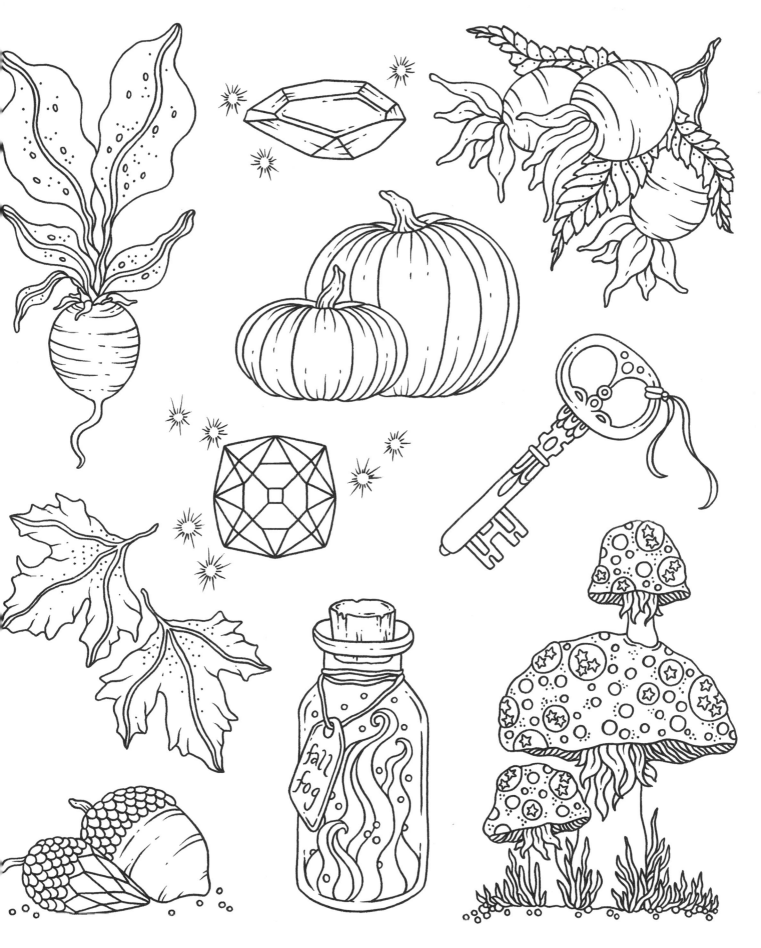

fall
fog

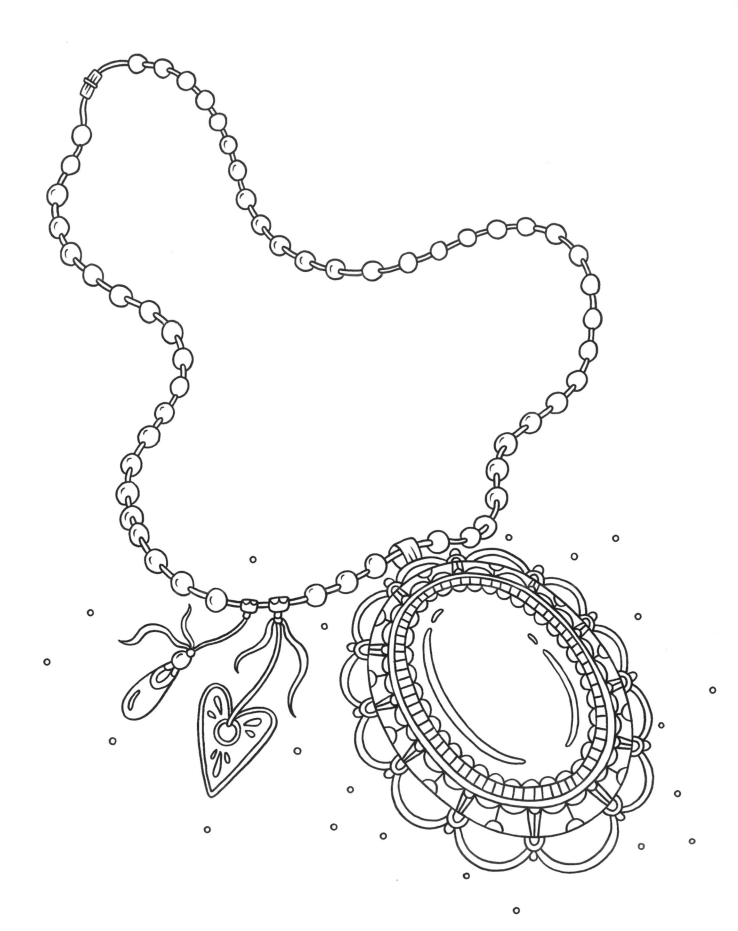

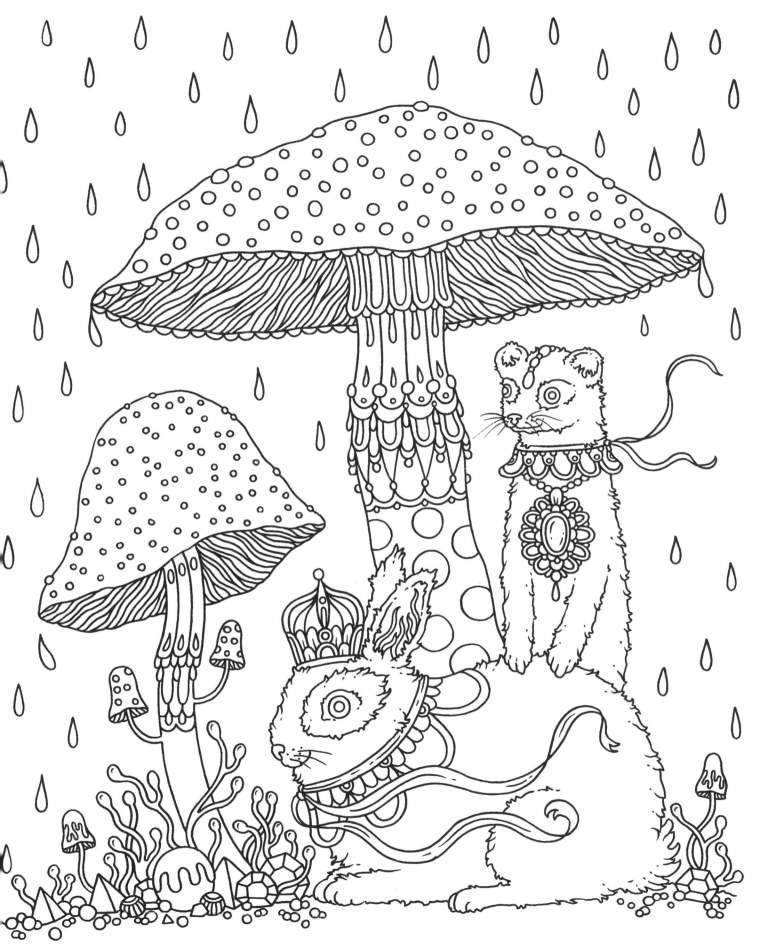

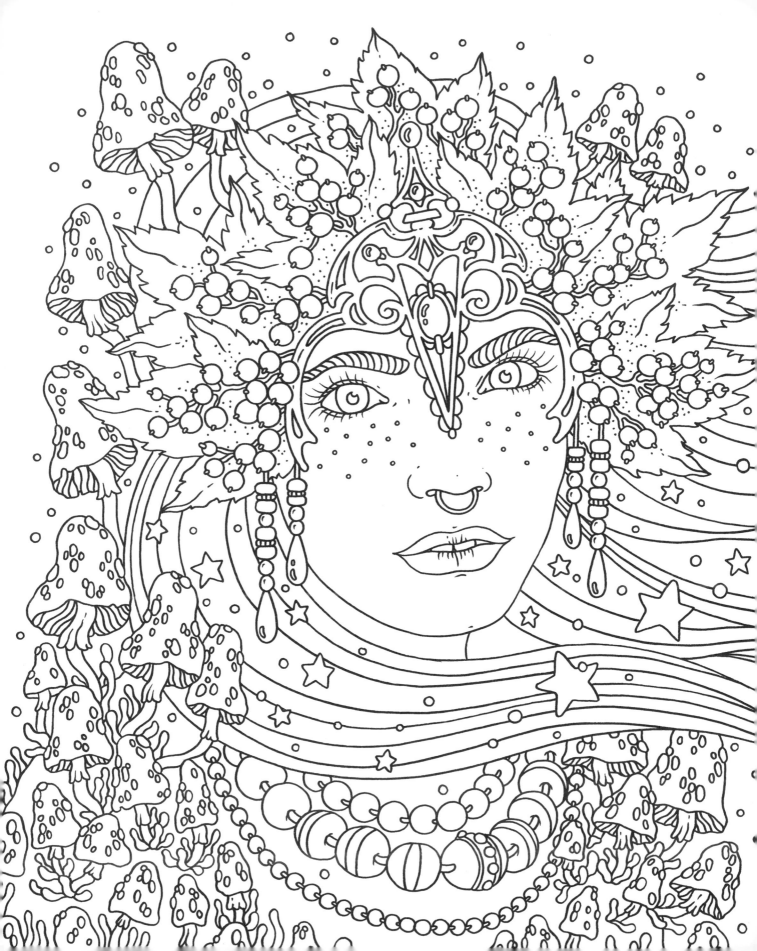

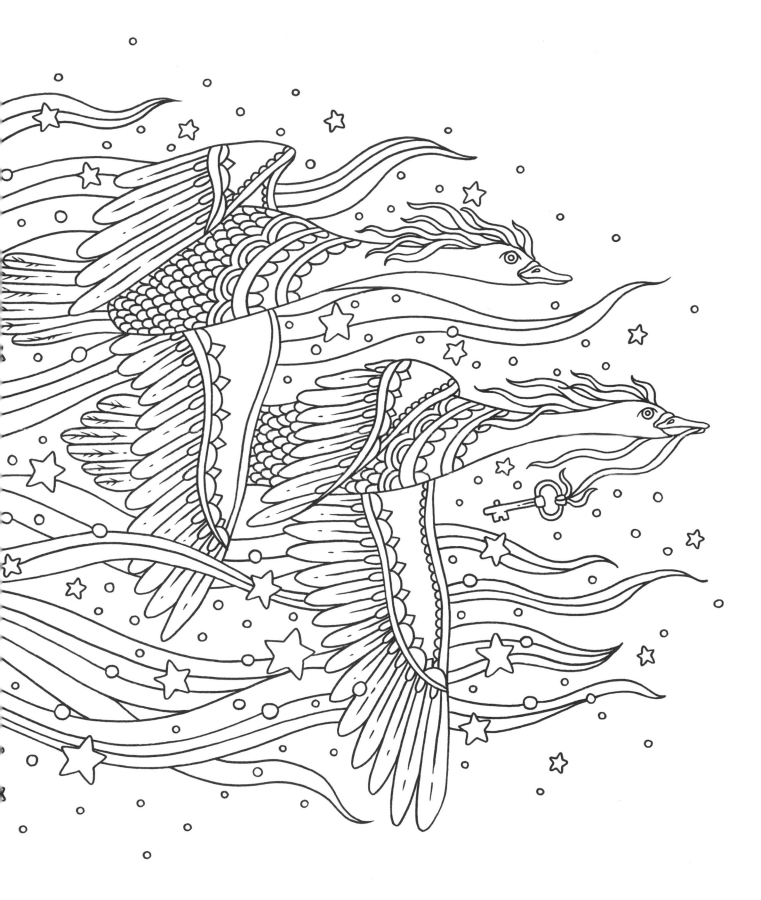

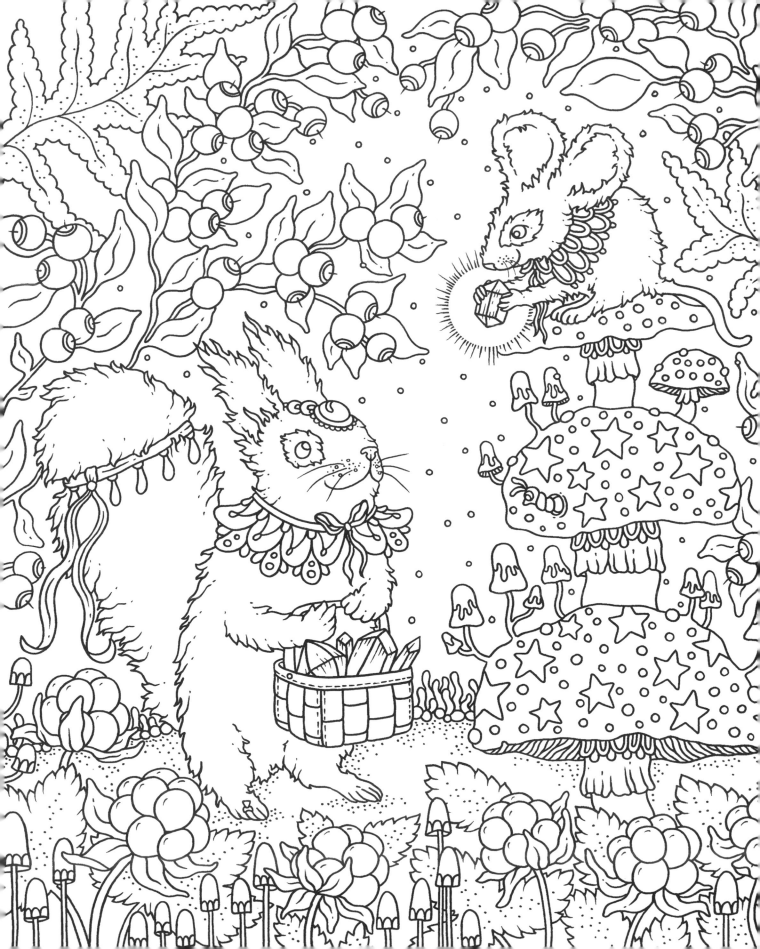

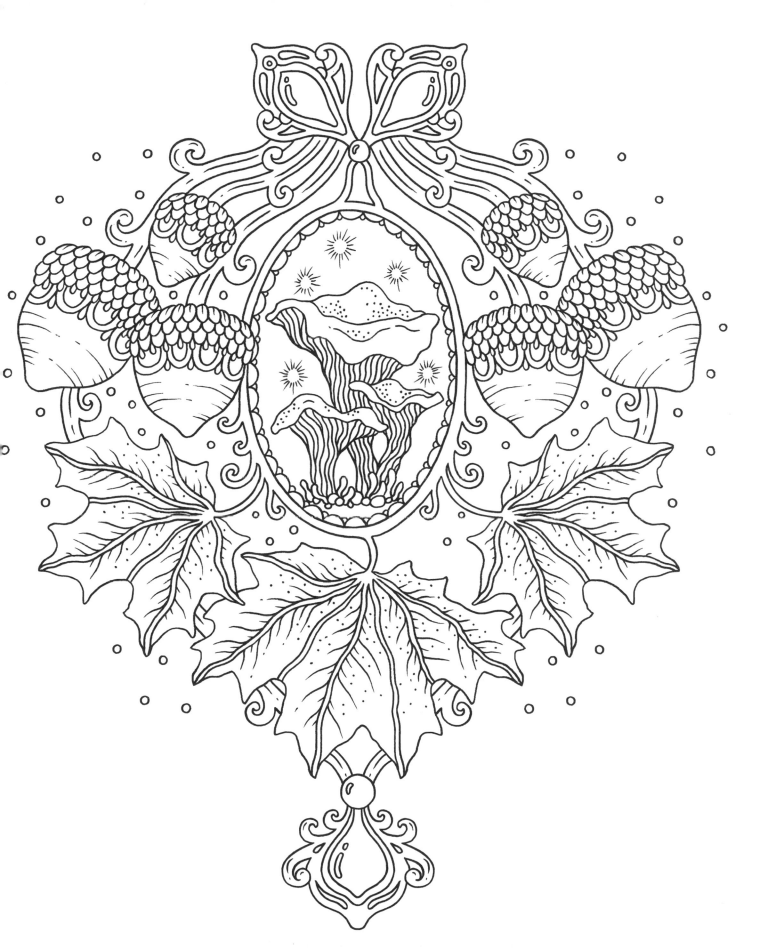

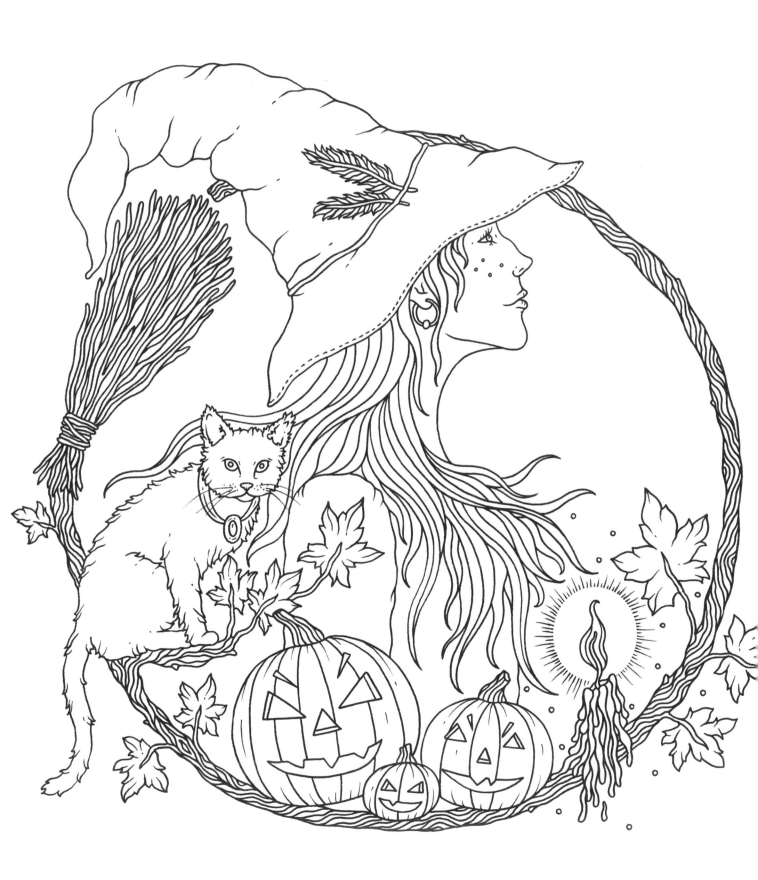

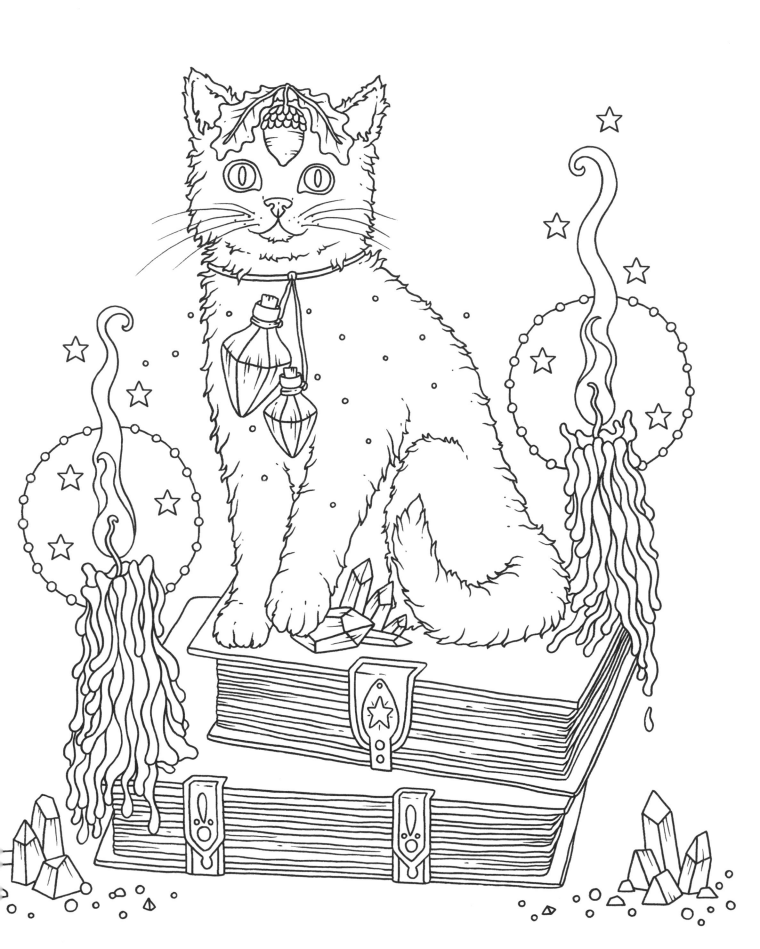

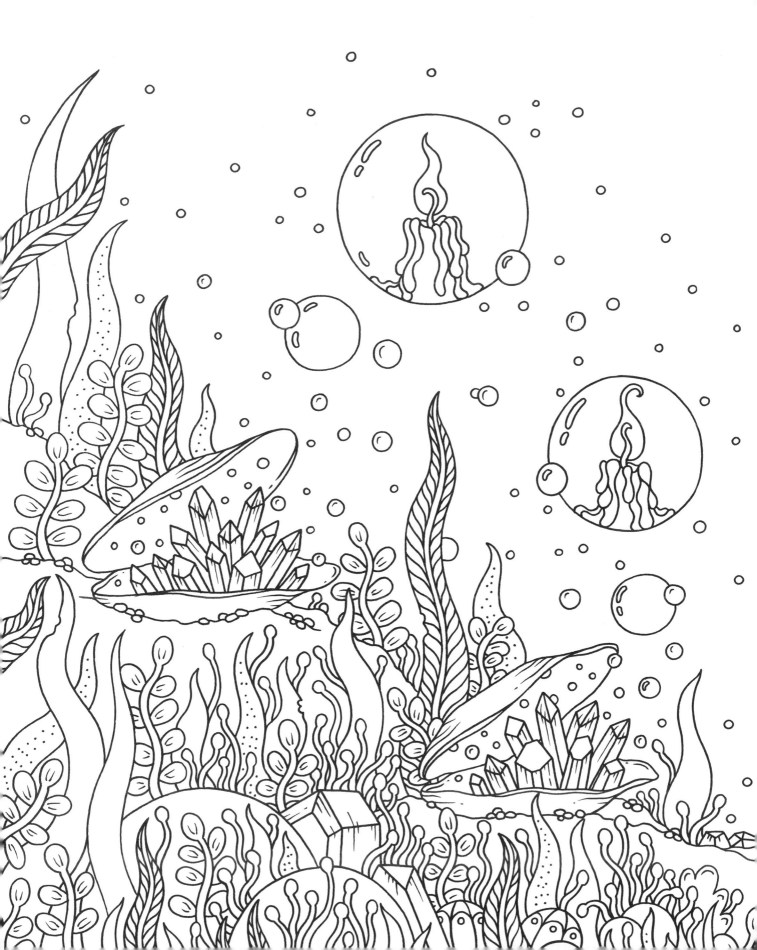

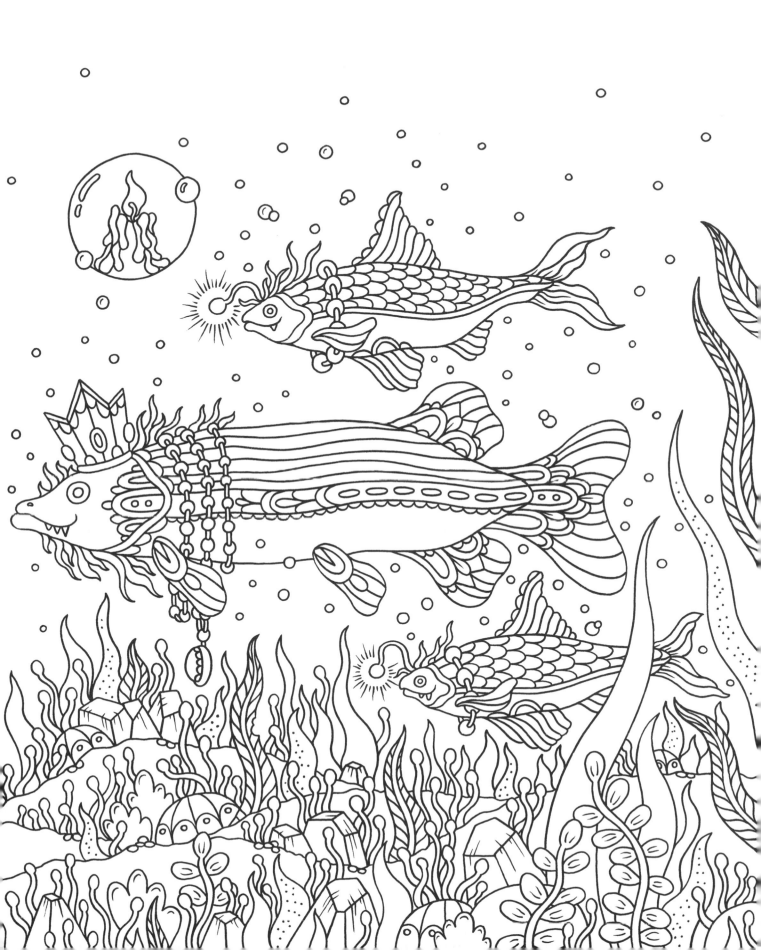

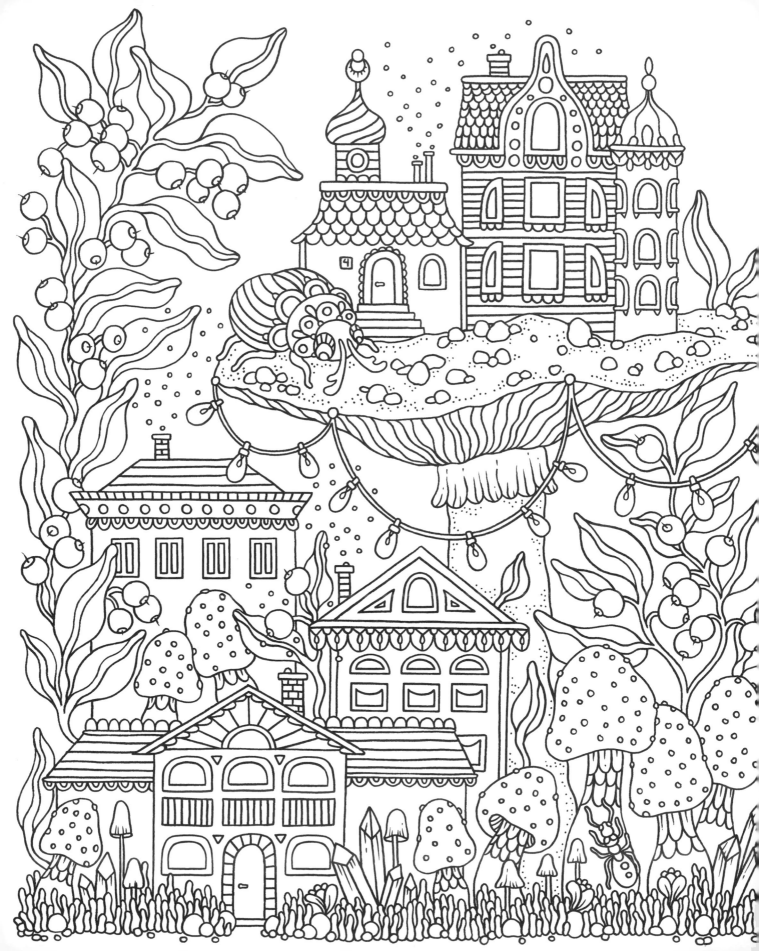

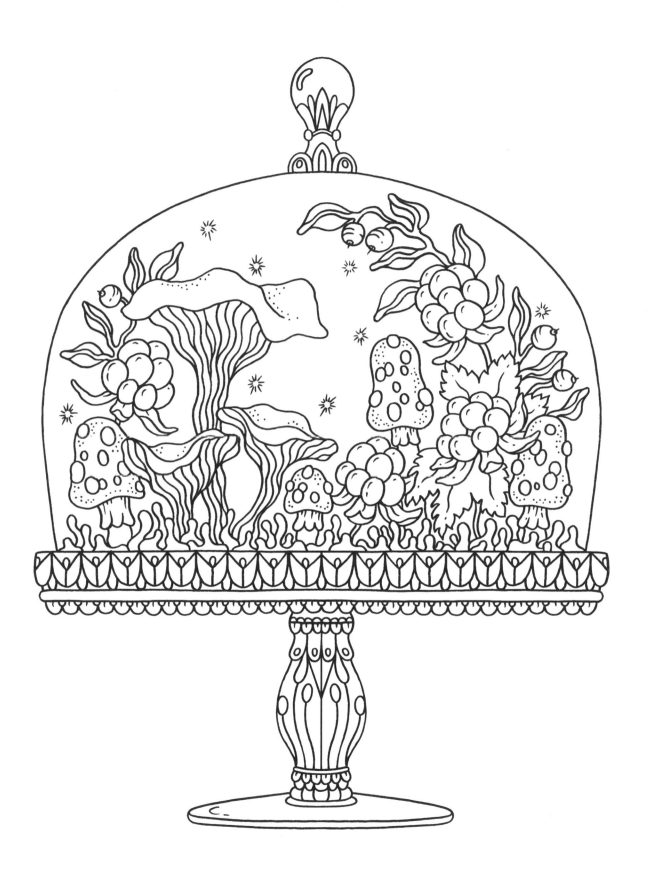

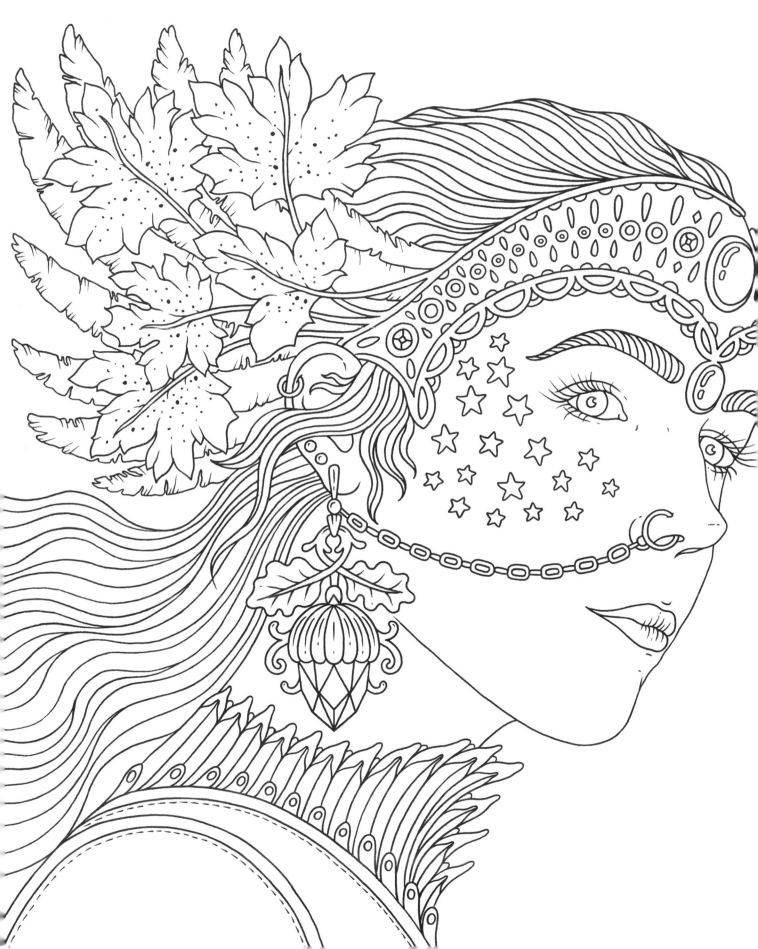

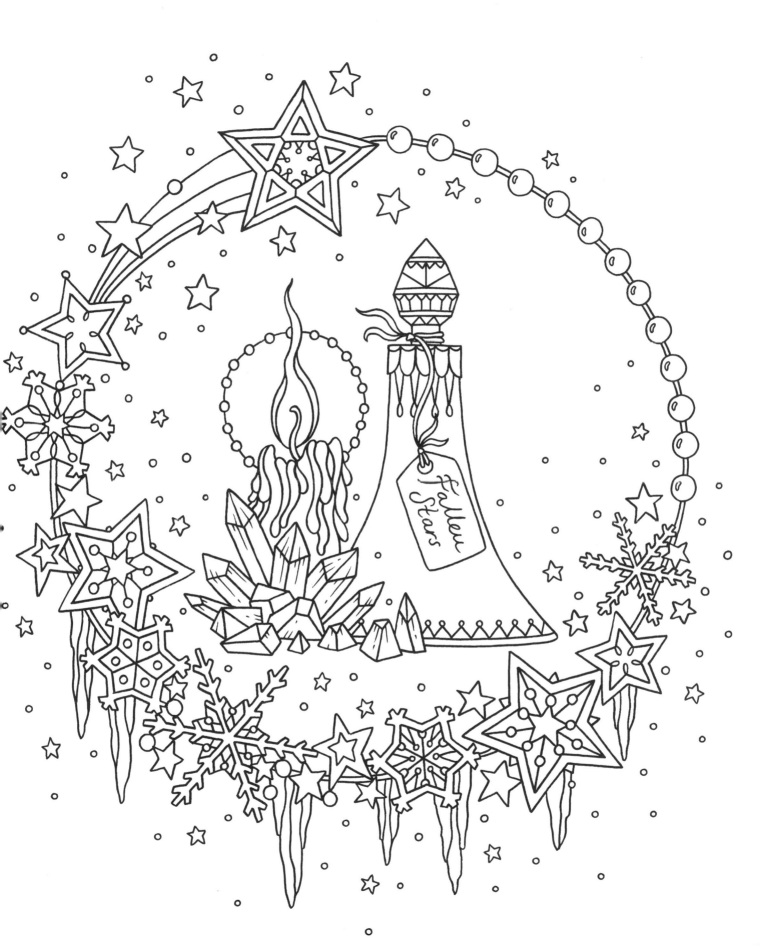

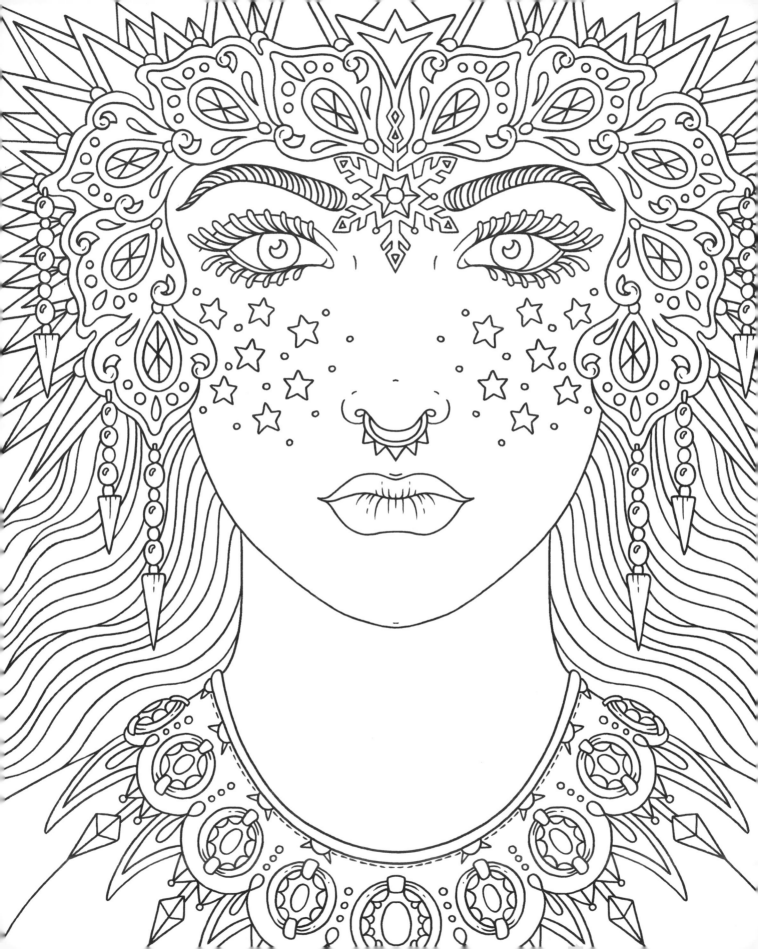

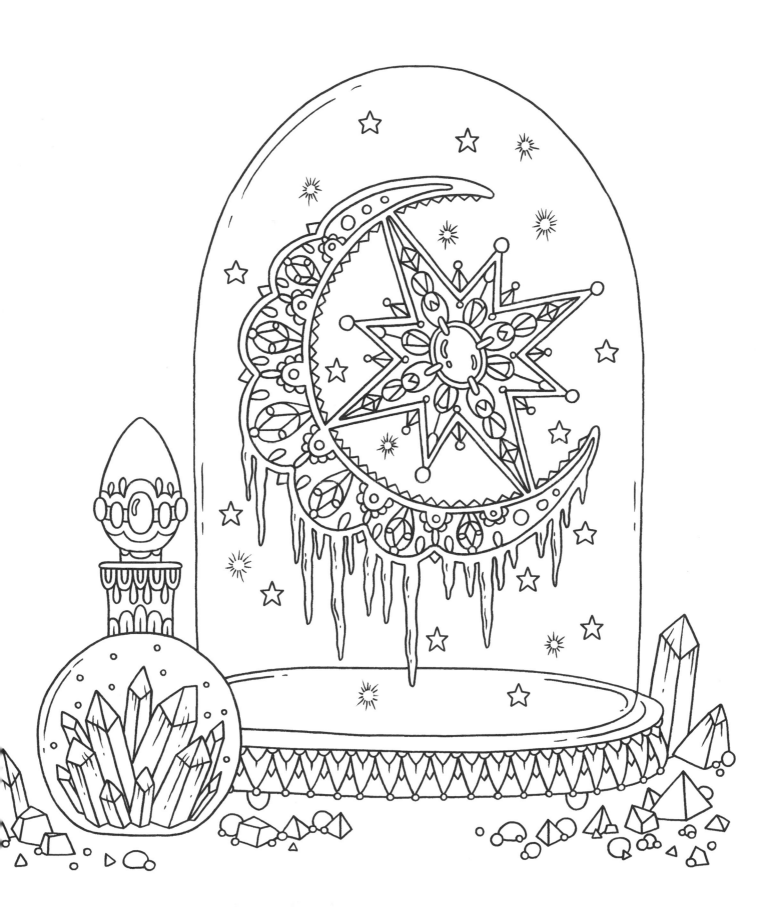

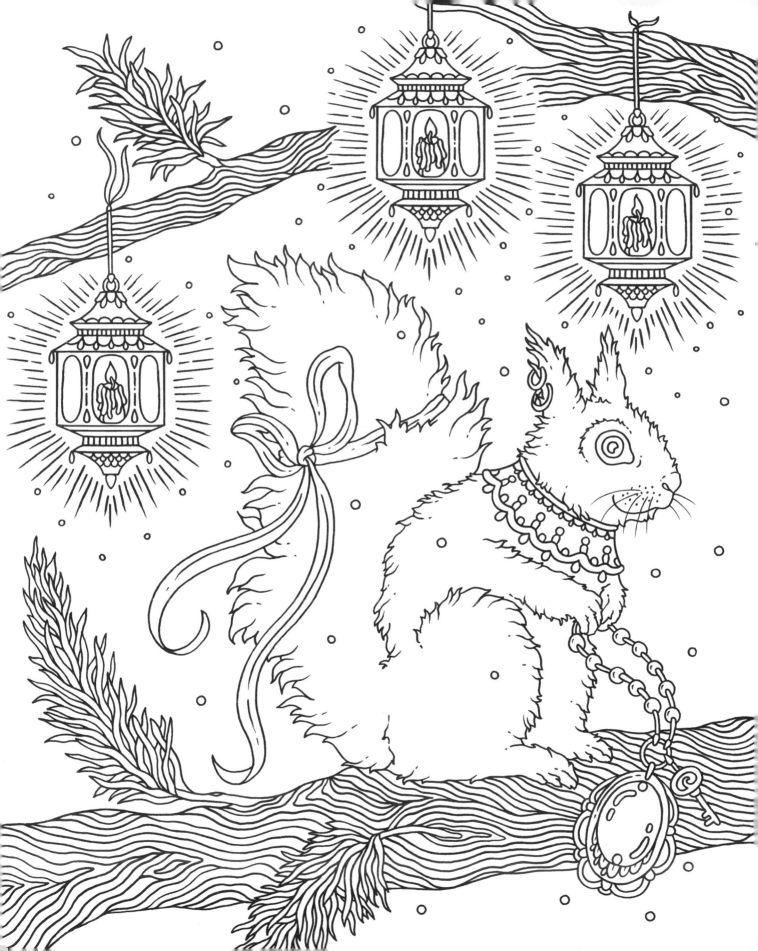

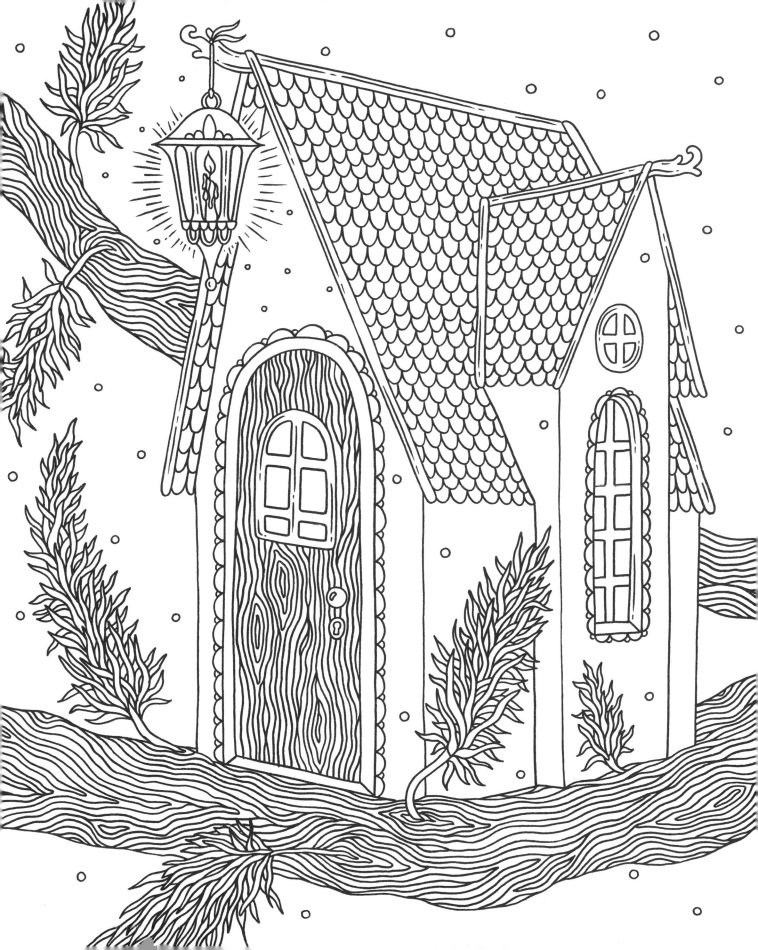

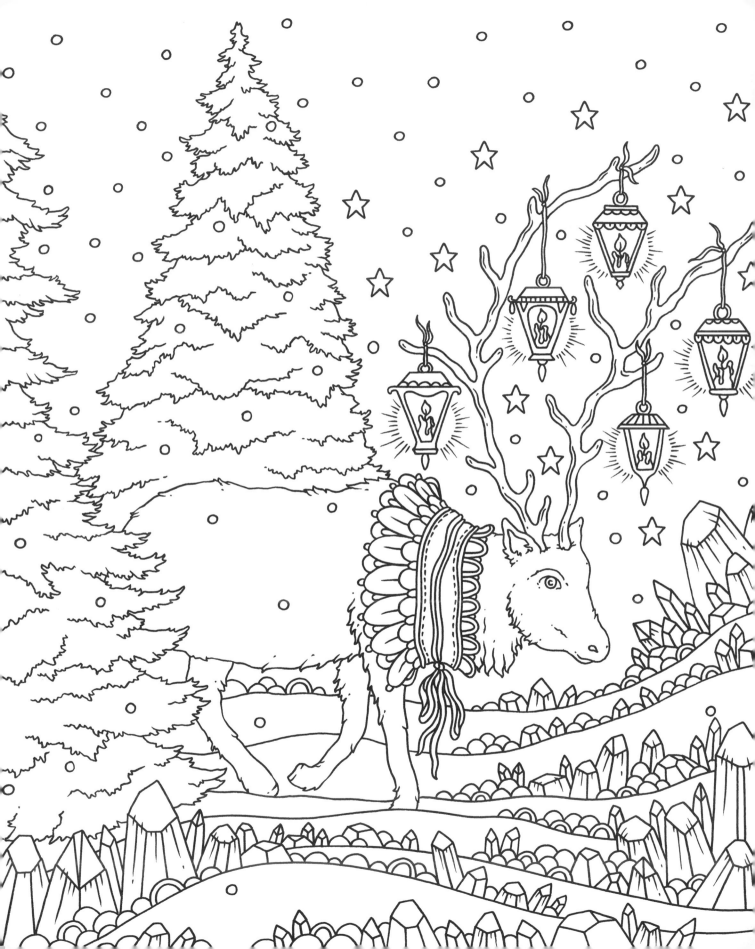

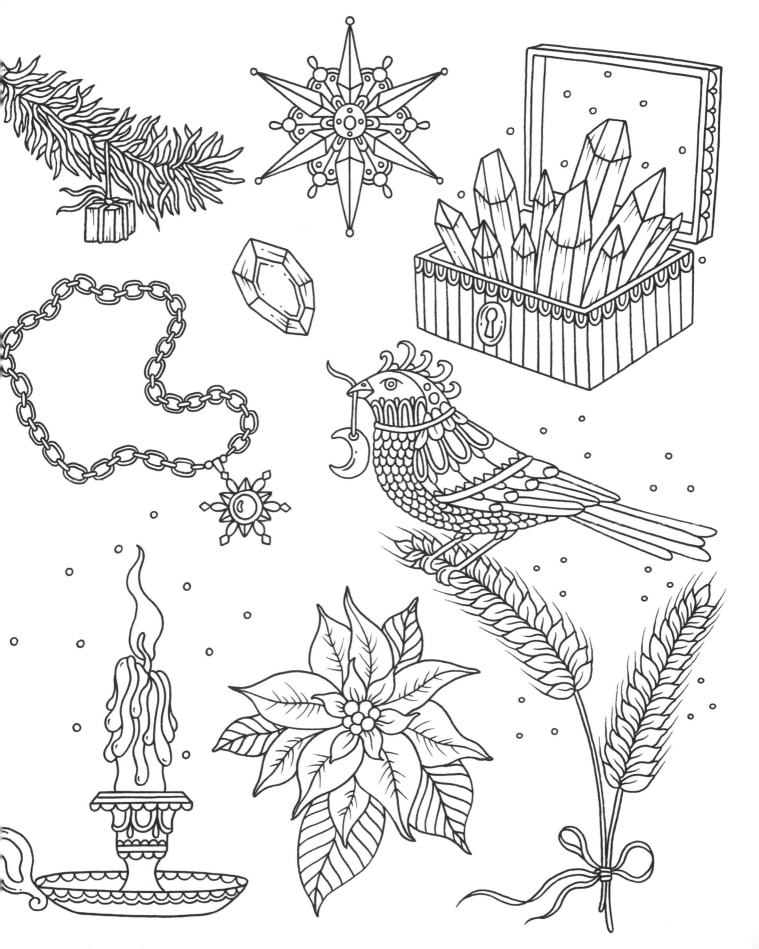

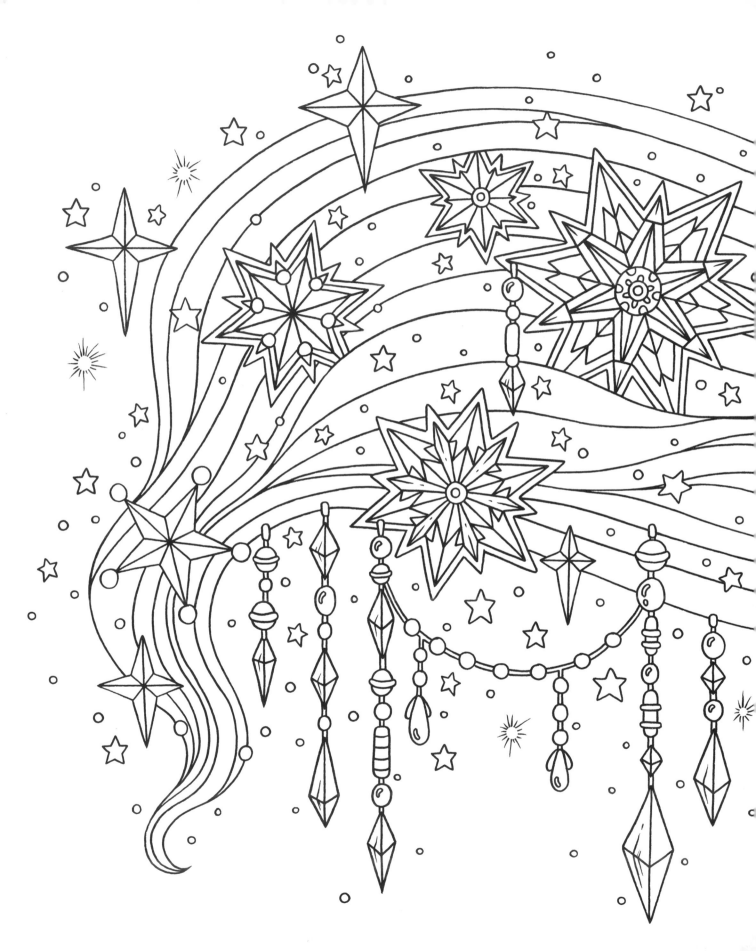

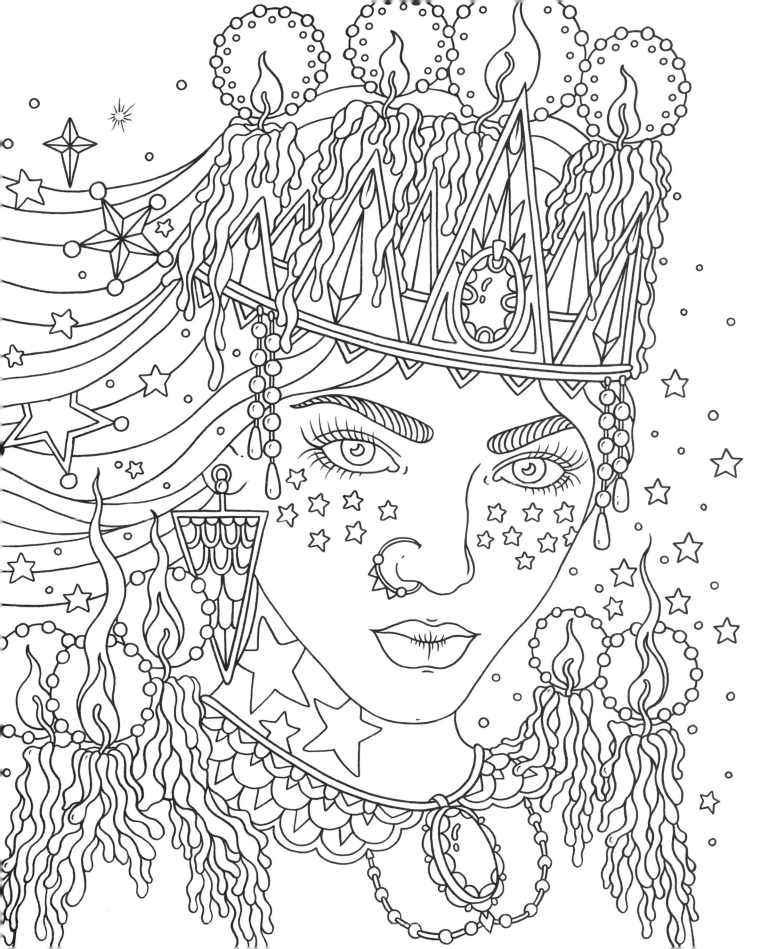

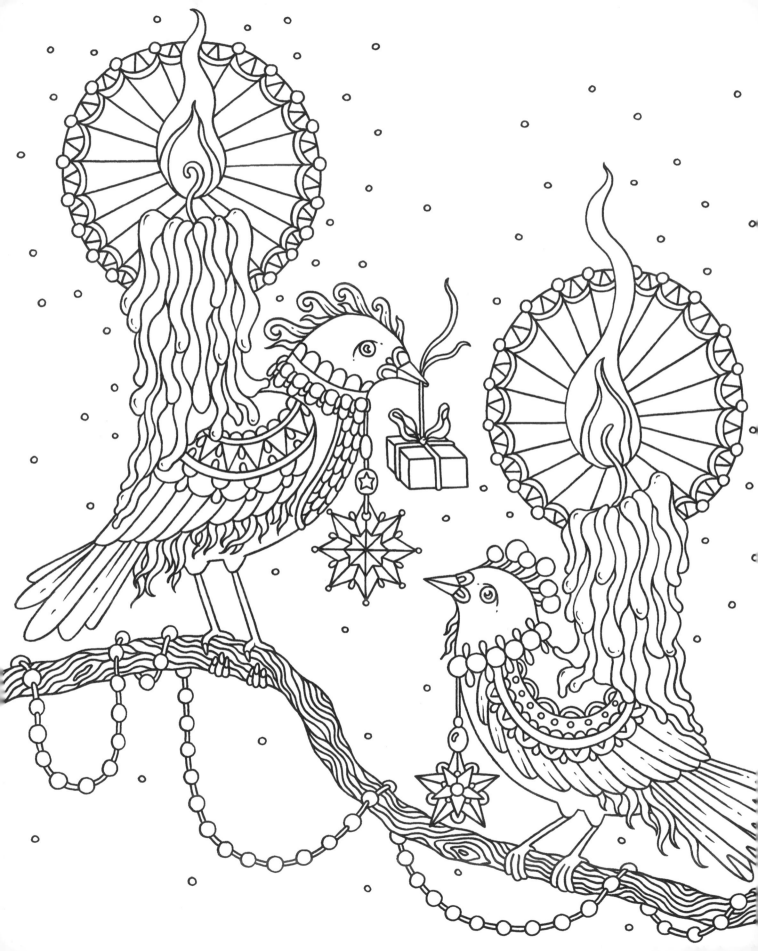

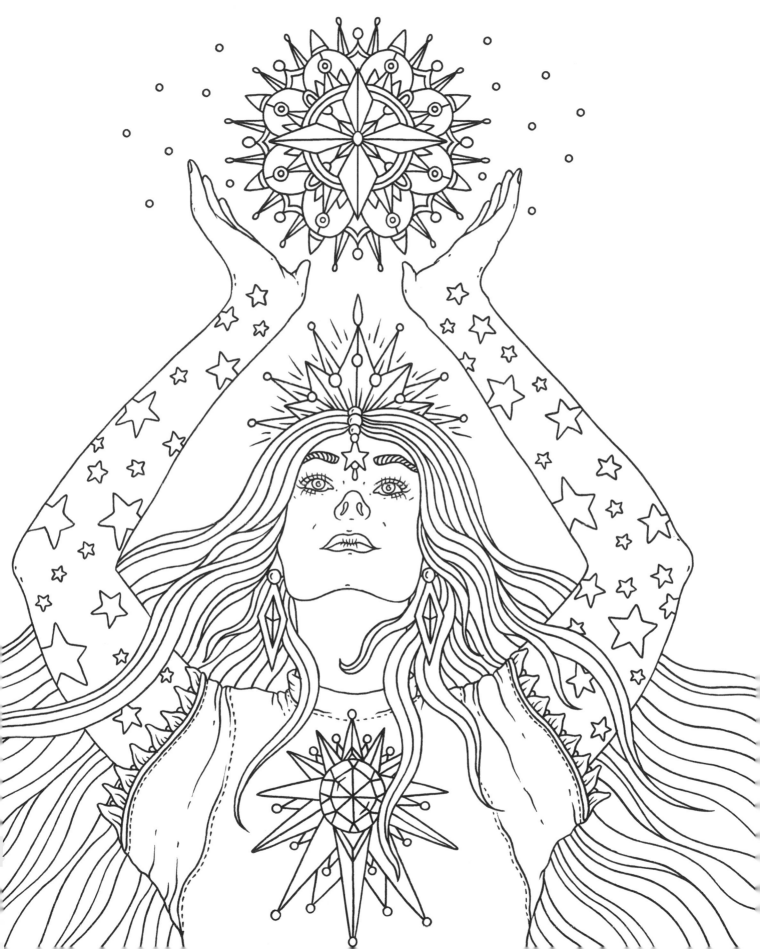

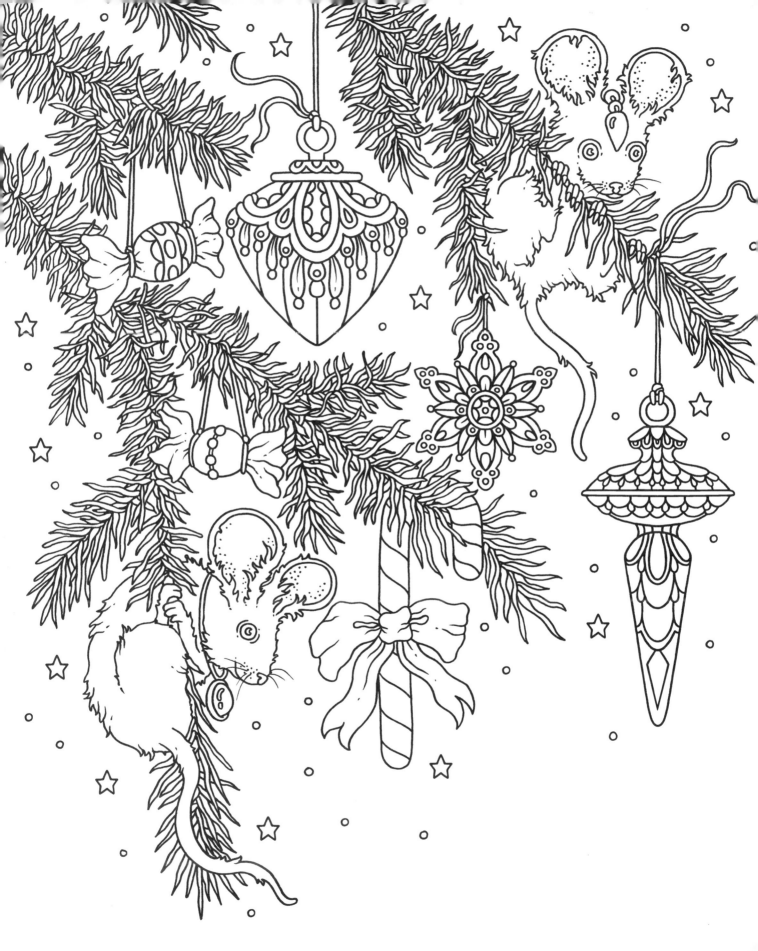

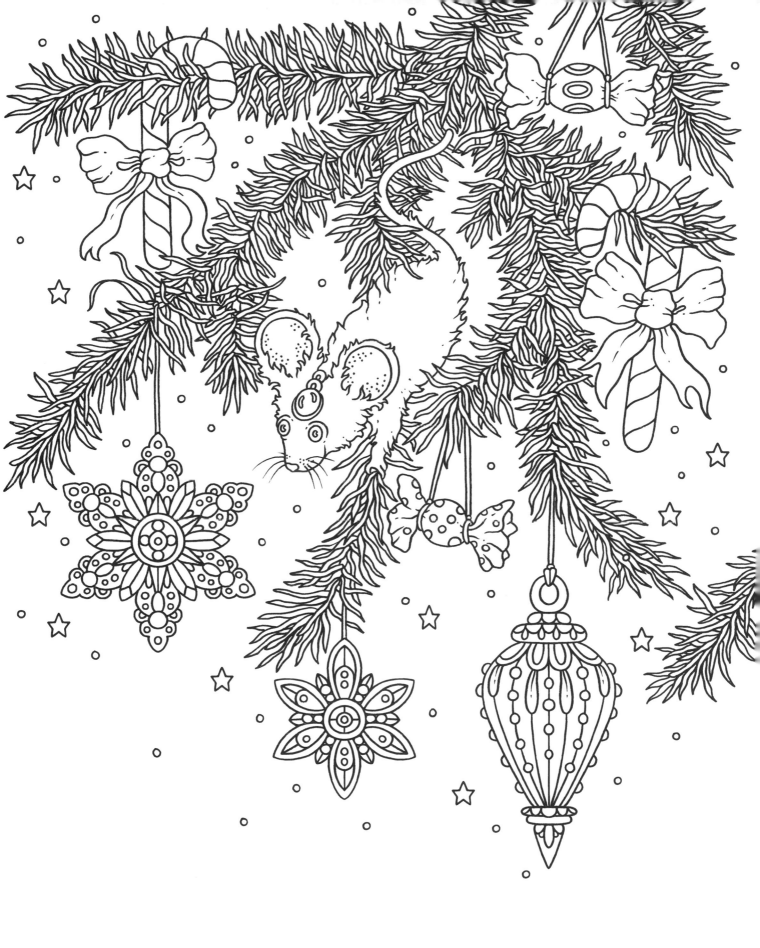

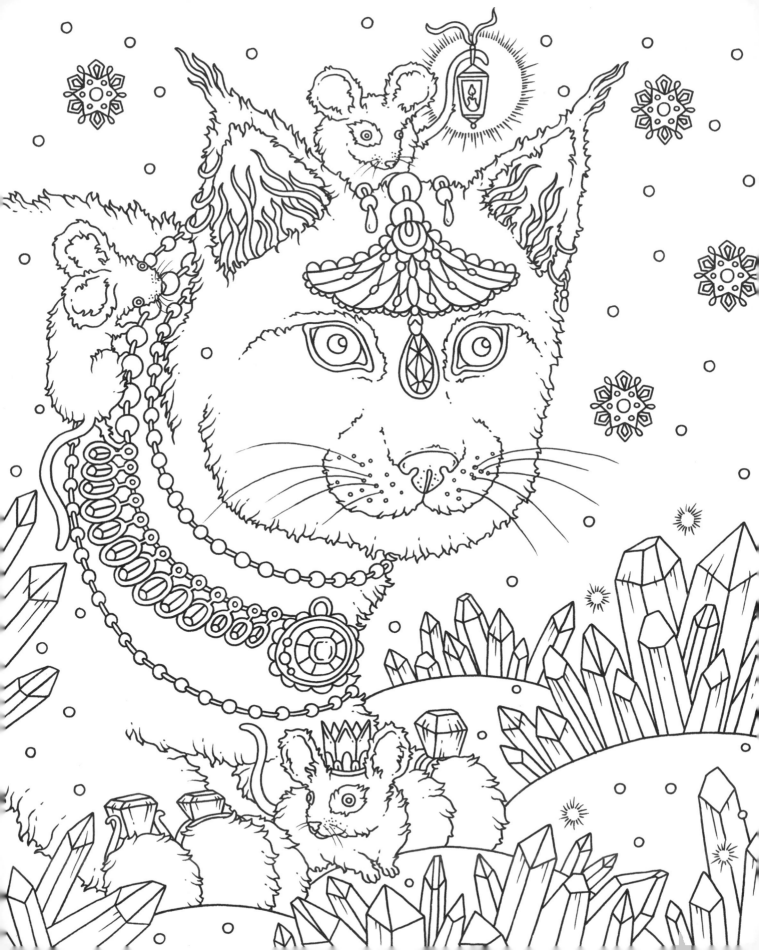

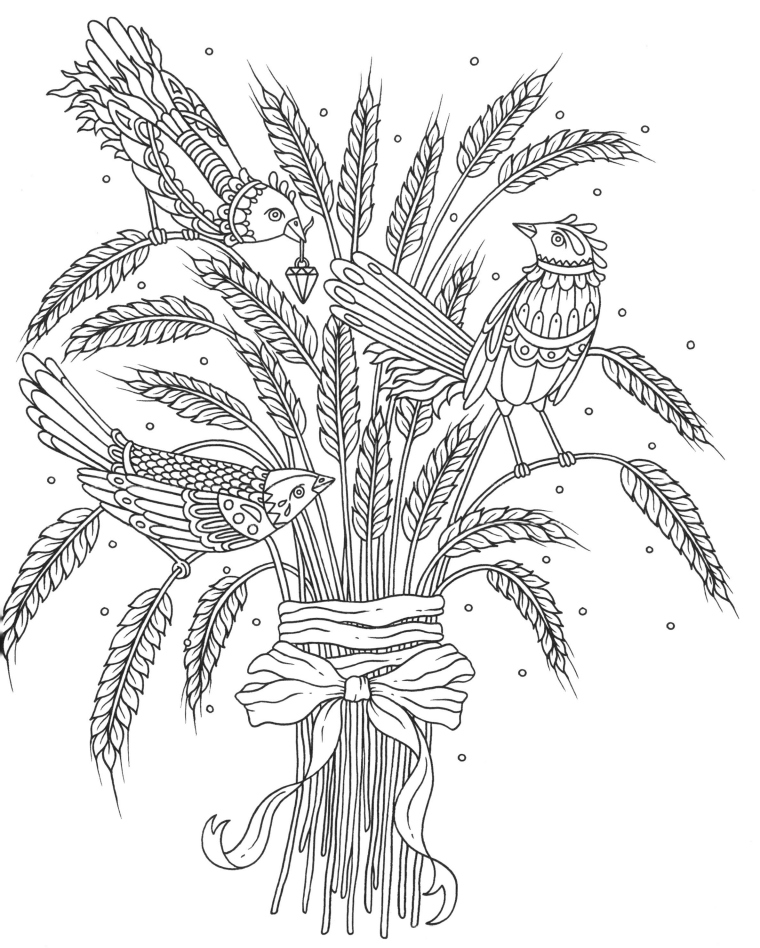

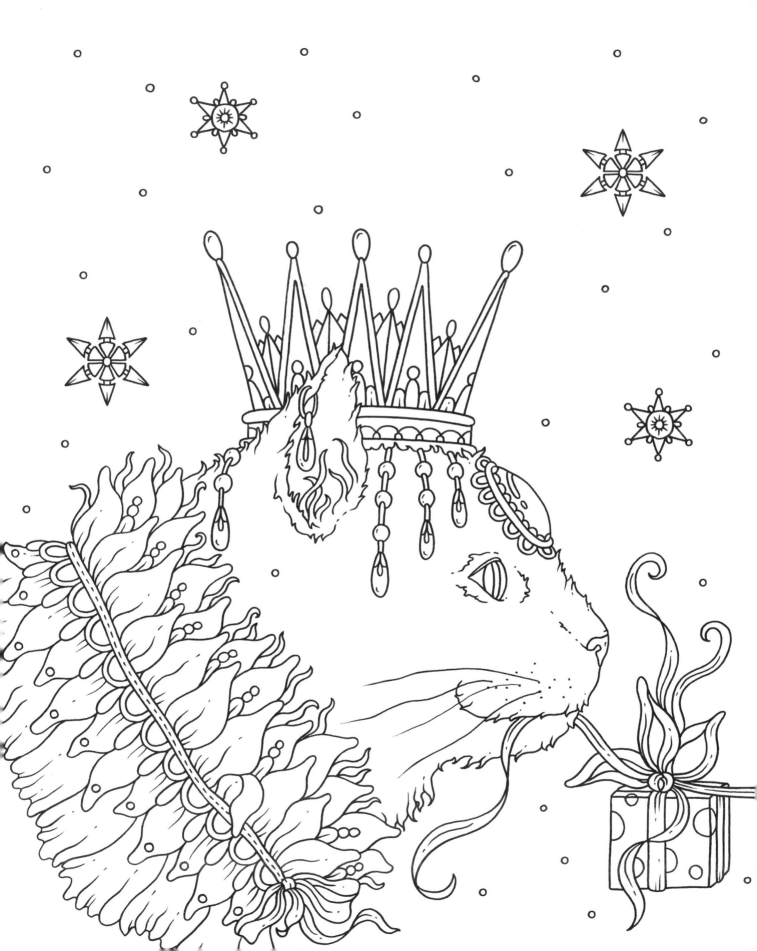

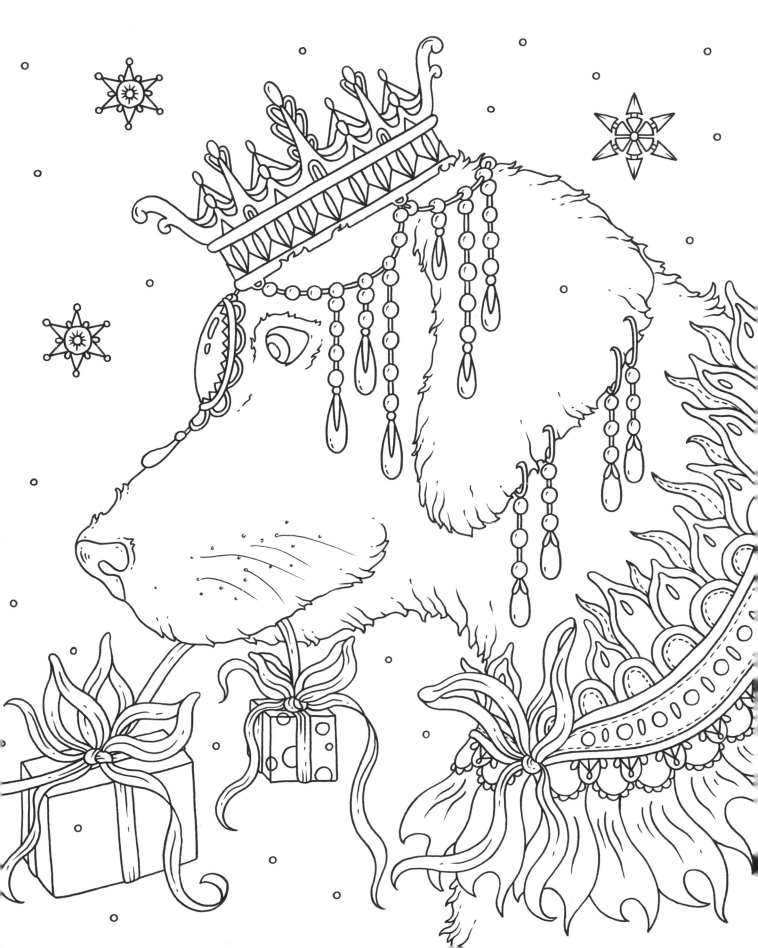

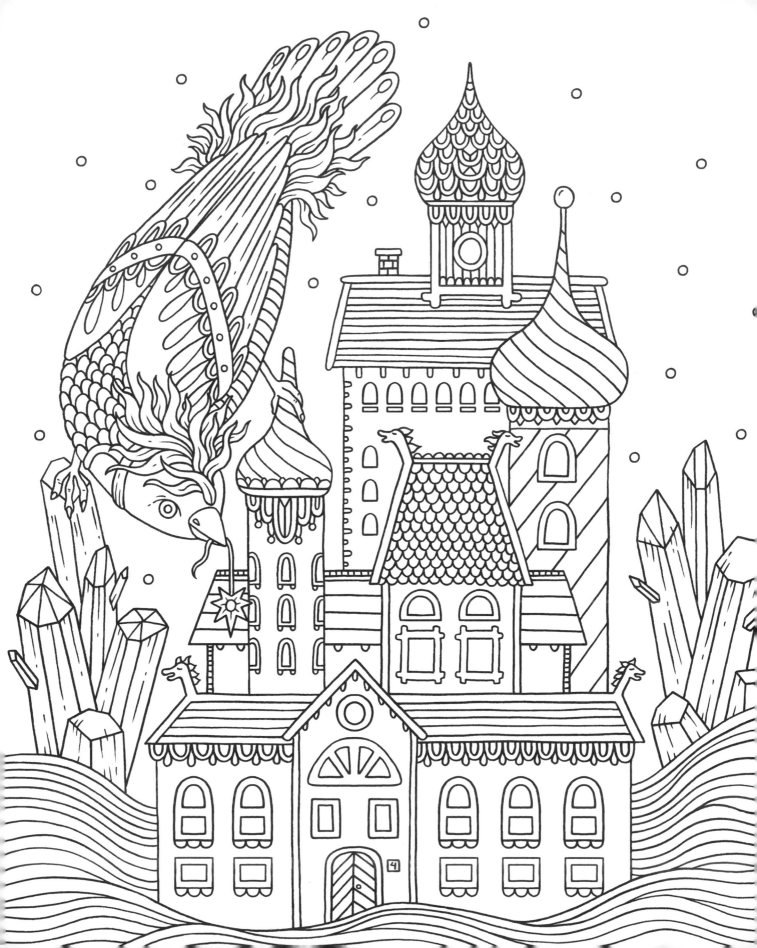

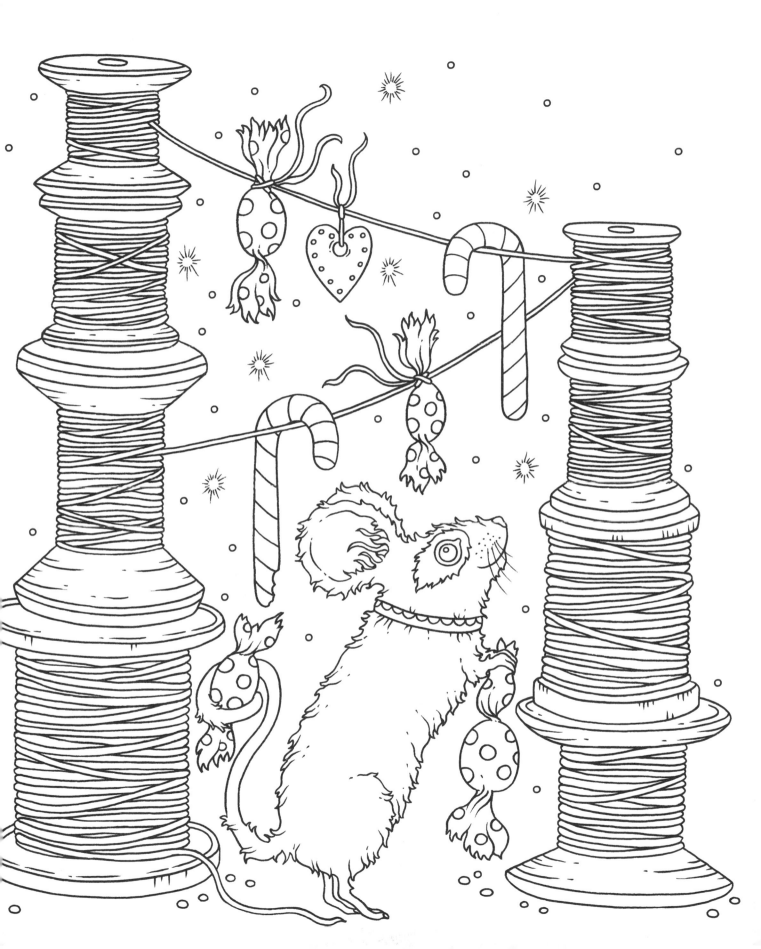

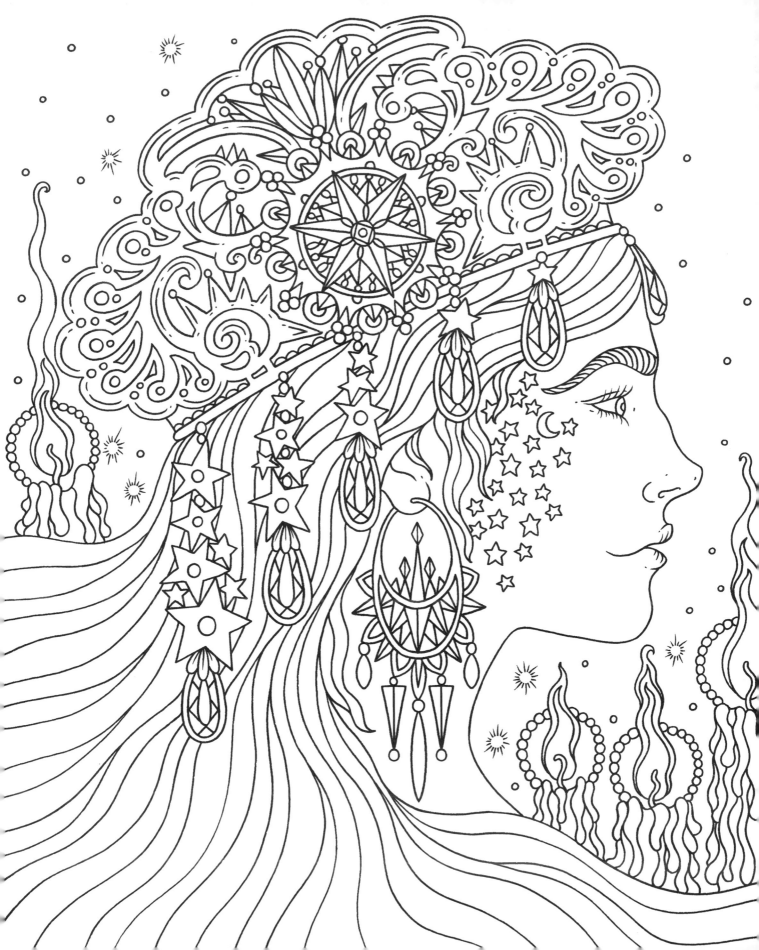

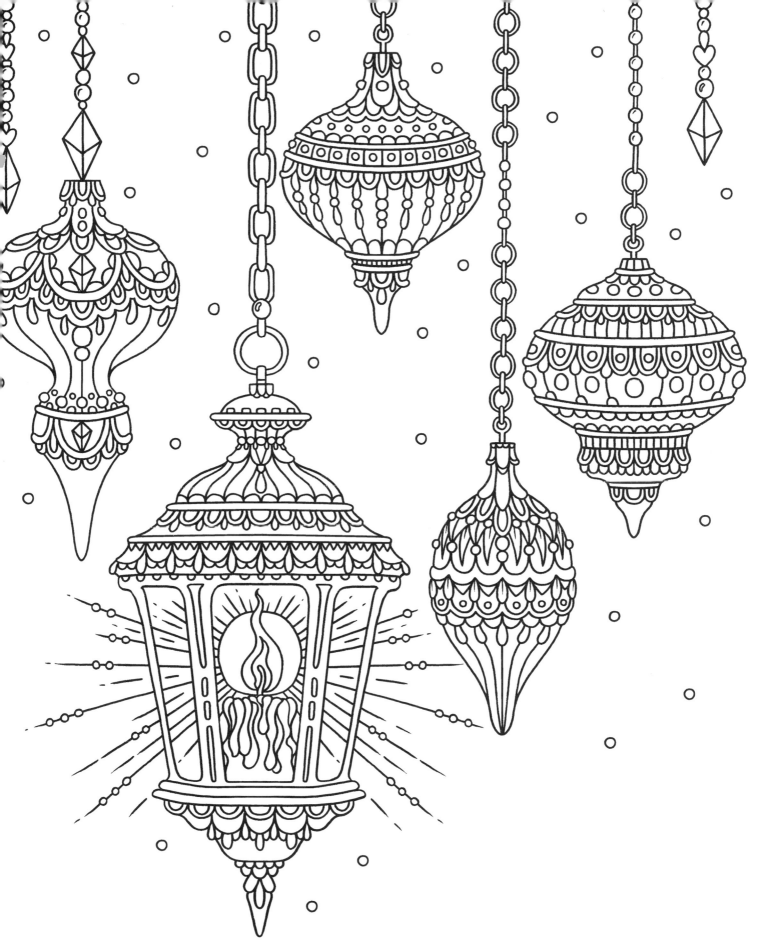

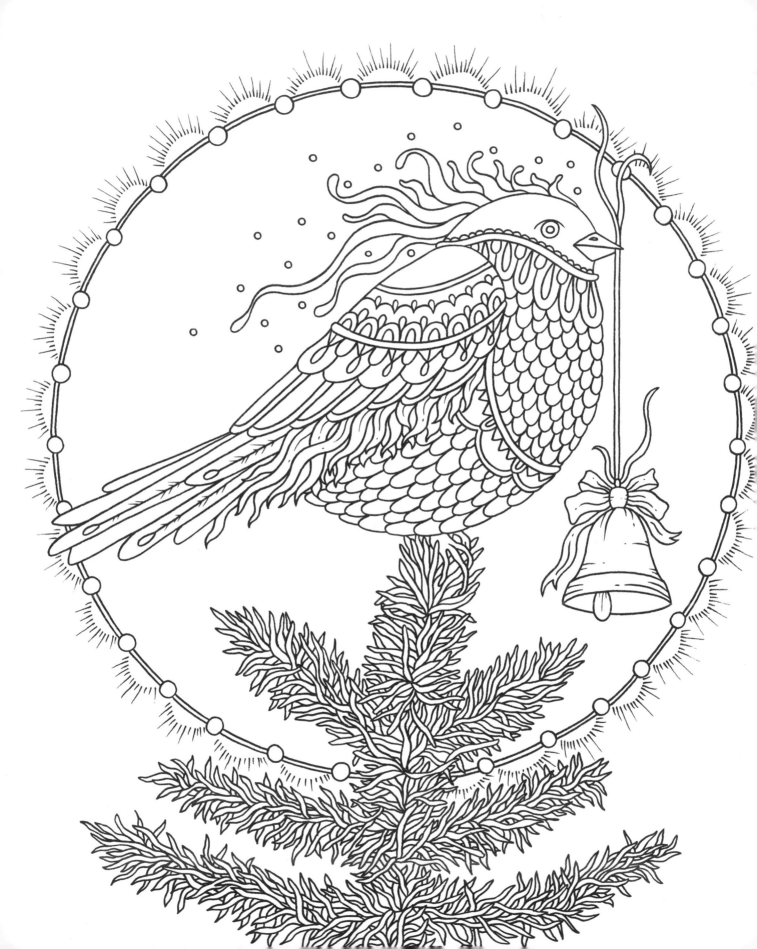